M000318063

3 9082 14272 1946

IMAGES
of America

WALNUT STREET THEATRE

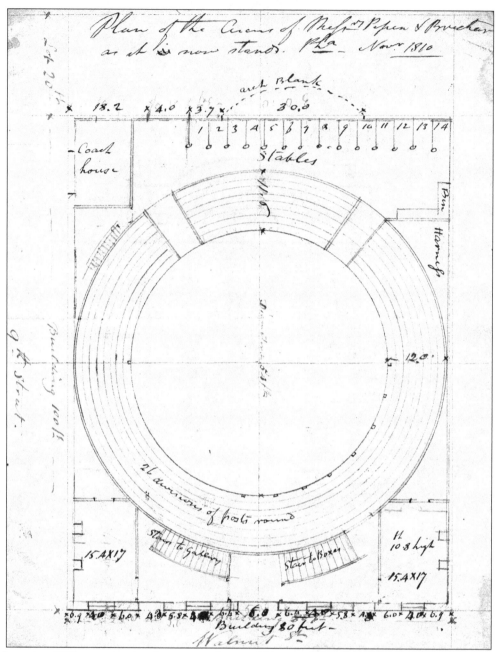

In spring 1808, construction began on what would become Victor A. Pepin and Jean Baptiste Casmiere Breschard's New Circus on Walnut Street. The building was 80 feet along Walnut Street and 100 feet along Ninth Street. The interior was similar to European circuses, with a riding ring in the center of the building surrounded by a raked seating area for the audience. This diagram depicts the interior as it was in 1810. (Courtesy of the Architectural Archive, Special Collections, Tulane University Libraries.)

On the cover: The Walnut Street Theatre is pictured around 1900. (Courtesy of the Library of Congress, Prints and Photographs Division.)

IMAGES
of America

WALNUT STREET THEATRE

Bernard Havard and Mark D. Sylvester

ARCADIA
PUBLISHING

Copyright © 2008 by Bernard Havard and Mark D. Sylvester
ISBN 978-1-5316-3700-2

Published by Arcadia Publishing
Charleston SC, Chicago IL, Portsmouth NH, San Francisco CA

Library of Congress Catalog Card Number: 2007935855

For all general information contact Arcadia Publishing at:
Telephone 843-853-2070
Fax 843-853-0044
E-mail sales@arcadiapublishing.com
For customer service and orders:
Toll-Free 1-888-313-2665

Visit us on the Internet at www.arcadiapublishing.com

*Dedicated to the memory of Dorothy Haas, whose generosity
made the chronicling of the Walnut Street Theatre's history possible.
It is also dedicated to all the audiences, artists, managers, employees,
board members, and donors who have kept America's oldest theater
alive for two centuries.*

CONTENTS

Acknowledgments 6

Introduction 7

1. Beginnings to 1849 9

2. From 1850 to 1899 23

3. From 1900 to 1940 43

4. From 1941 to 1968 65

5. From 1969 to 1982 103

6. From 1983 to 2007 113

ACKNOWLEDGMENTS

Except as noted, all images in the book are from the archives of the Walnut Street Theatre. We are grateful to Andrew Davis, who has extensively researched the Walnut Street Theatre's history. This book would not have been possible without the assistance of Geraldine Duclow of the Free Library of Philadelphia's Theatre Collection and Jessica Doheny. We would also like to thank Stephanie Michael and Mark Garvin for their contributions. The Walnut Street Theatre Company photographs in chapter 6 were taken by Coy Butler, Mark Garvin, Gerry Goodstein, Ken Kauffman, Stan Sadowski, and Brett Thomas.

INTRODUCTION

Standing at the corner of Ninth and Walnut Streets in Philadelphia for 200 years, the Walnut Street Theatre's national historic landmark structure has housed two centuries' worth of American popular entertainment. Most noteworthy American actors of the 19th century and many from the 20th century have appeared onstage at the Walnut. Some of the Walnut's shining stars include Edwin Forrest, Edwin Booth, Edmund Kean, the Drews, the Barrymores, George M. Cohan, Will Rogers, the Marx Brothers, Helen Hayes, Henry Fonda, Katharine Hepburn, Marlon Brando, Jessica Tandy, Ethel Waters, Audrey Hepburn, Sidney Poitier, Lauren Bacall, George C. Scott, Jane Fonda, Robert Redford, Julie Harris, Jack Lemon, and William Shatner. Over the years, audiences have clapped and cheered for circuses, operas, vaudeville, lectures, music, dance, motion pictures, and, of course, the live theater productions for which it is best known today.

When the theater opened its doors on February 2, 1809, the pounding of hooves mingled with the shrieks of delight from the crowd as teams of horses circled a dirt riding ring. A few years later, an 80-foot dome was added to the theater, making it the tallest structure in Philadelphia at that time. The theater's career as an equestrian circus did not last long, however, and by 1812, the building had been converted to a legitimate theater, featuring a real stage where the ring had stood. The Walnut's first theatrical production, *The Rivals*, had Pres. Thomas Jefferson and the Marquis de Lafayette in attendance on opening night.

In 1820, Edwin Forrest, a young Philadelphian who would have a profound impact on American drama, made his professional debut on the Walnut stage at age 14. In 1828, John Haviland, the most prominent architect of his day, designed major renovations to the interior and exterior of the building. The present facade is based on his original design.

The Walnut Street Theatre is home to many firsts in the American theater scene. In 1837, the Walnut was the first theater to install gas footlights, and in 1855, the Walnut became the first theater to install air-conditioning. The first copyright law protecting American plays had its roots at the Walnut. The curtain call, now a tradition in every theater, started at the Walnut with the post-play appearance of noted 19th-century actor Edmund Kean.

In 1863, the theater was purchased by Edwin Booth, a son of one of the most famous theatrical families of the day. Unfortunately, fame would soon turn to notoriety for Booth when his brother John Wilkes Booth assassinated the president at Ford's Theatre in Washington, D.C. Edwin Booth, with his business partner and brother-in-law, John Sleeper Clarke, managed to hold on to the Walnut in those dark days and go on to guide it for many years.

During the 1880s, the Walnut experienced many renovations, including a new stage for more elaborate musical comedies. In 1920, the interior was again rebuilt within the old exterior using structural steel in a design by William H. Lee.

The Walnut remained a significant player on the American theater scene throughout the 20th century. Purchased by the Shubert Organization in the 1940s, the theater was home to many pre-Broadway tryouts of plays that would go on to become American classics, such as *A Streetcar Named Desire* starring Marlon Brando, *A Raisin in the Sun* featuring Sidney Poitier, and *The Diary of Anne Frank* featuring Susan Strasberg. *Mister Roberts*, starring Henry Fonda, opened at the Walnut in 1948. Fonda, recently discharged from the navy, used his own uniform in the play. His daughter Jane Fonda appeared in *There Was a Little Girl* in 1960. In 1961, Neil Simon's first Broadway play, *Come Blow Your Horn,* debuted.

The Walnut's rich history is evident backstage as well, as it is one of only a few remaining "hemp houses" in the country. To this day, it continues to operate the original grid, rope, pulley, and sandbag system that was in use nearly two centuries ago. The theater's hand-painted fire curtain, which still hangs above the stage, displays a reproduction of the *The Liberty Bell's First Note, 1753*, originally painted by Jean Leon Gerome Ferris.

In 1964, the Walnut Street Theatre was designated a national historic landmark. Then in 1969, the theater was renovated again to become a performing arts center. During this period, a variety of live entertainments were represented at the Walnut, including dance, music, and theater. In 1976, the Walnut hosted the first televised Jimmy Carter–Gerald R. Ford presidential debate.

The Walnut began its most recent incarnation as a self-producing, nonprofit regional theater when Bernard Havard took the helm in 1982, founding the Walnut Street Theatre Company with a vision of once again creating theater in a space that is so steeped in the American theater's traditions and history. Today one can experience the realization of that dream when attending a live performance. With over 56,000 subscribers annually, the Walnut Street Theatre is the most subscribed theater company in the world.

To learn more about the Walnut and its history, educational programs, and productions, visit www.walnutstreettheatre.org.

One

BEGINNINGS TO 1849

Jean Baptiste Casmiere Breschard, as seen in this painting by Gilbert Stuart, was a native of France. His partner, Victor A. Pepin, of whom there are no known images, was born in Albany, New York, and taken to France as a young boy. In addition to being circus entrepreneurs, they were both established equestrian performers. They would go on to build arenas similar to the New Circus in cities throughout the northeastern United States and appear at them annually. (Courtesy of the Board of Trustees, National Gallery of Art, Washington. Gift of Mrs. Robert B. Noyes in memory of Elisha Riggs.)

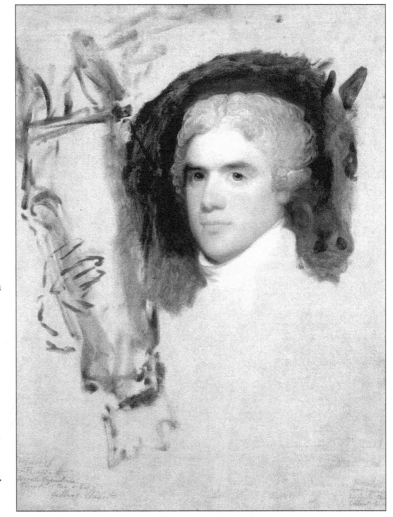

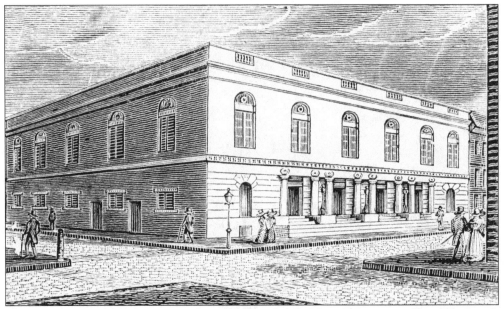

Victor A. Pepin and Jean Baptiste Casmiere Breschard's New Circus opened on February 2, 1809, with a show that featured eight lavishly costumed equestrian riders performing military exercises choreographed to music. A few years later, an 80-foot dome was added to the theater, making it the tallest structure in Philadelphia at that time.

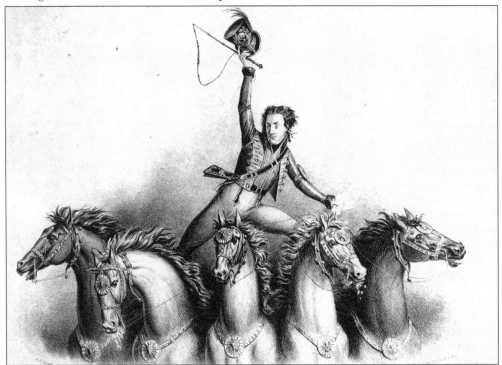

Circuses of the period were equestrian shows with four basic acts: hurdle riding, two-horse riding, leaps, and vaults. A skilled rider could leap between several horses. (Courtesy of Special Collections, Milner Library, Illinois State University.)

In the fall of 1811, a 40-foot addition with a stage was added to the north side of the building. The theater opened on New Year's Day 1812 with its first theatrical production, Richard Brinsley Sheridan's comedy *The Rivals*. In attendance on opening night were Pres. Thomas Jefferson (right) and the Marquis de Lafayette (below). (Right, courtesy of Hulton Archive/Stringer/Getty Images; below, courtesy of ND/Roger Viollet/Getty Images.)

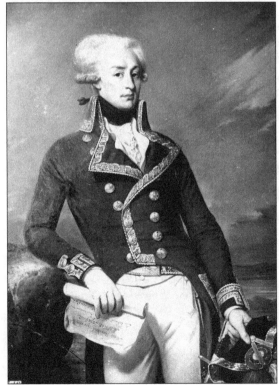

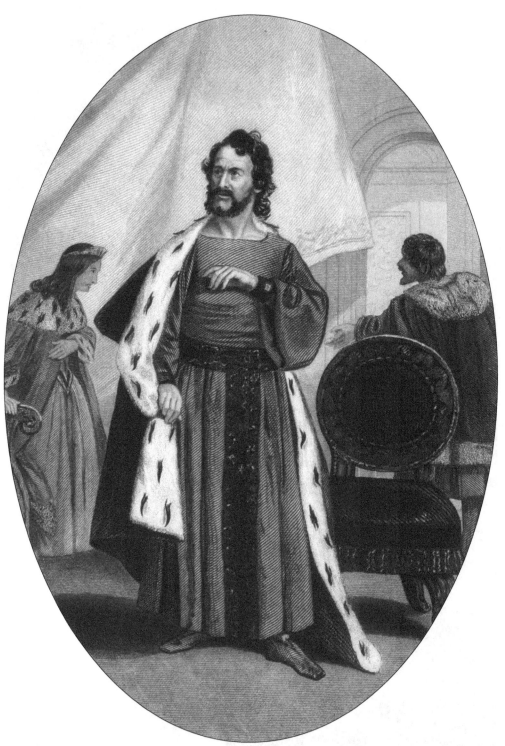

On February 3, 1812, *The Winter's Tale* opened. It was the first time that a Shakespearian play was performed in Philadelphia. This drawing was created for the first complete American printing of William Shakespeare's works.

At the age of 14, Edwin Forrest (right) made his Walnut Street Theatre debut on November 27, 1820. This Philadelphia native would soon rise to stardom. Unknown in 1820, he was billed simply as a "young gentleman of Philadelphia." A favorite debut role for young actors, he appeared as Young Norval in John Home's tragedy *Douglas* (below).

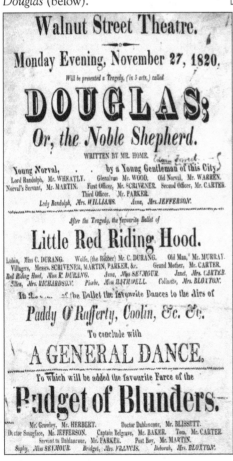

Walnut Street Theatre.

Monday Evening, November 27, 1820.

Will be presented a Tragedy, (in 5 acts,) called

DOUGLAS;
Or, the Noble Shepherd.

WRITTEN BY MR. HOME.

Young Norval, . . . by a Young Gentleman of this City.
Lord Randolph, Mr. WHEATLY. Glenalvon Mr. WOOD. Old Norval, Mr. WARREN.
Norval's Servant, Mr. MARTIN. First Officer, Mr. SCRIVENER. Second Officer, Mr. CARTER.
Third Officer. Mr. PARKER.
Lady Randolph, Mrs. WILLIAMS. Anna, Mrs. JEFFERSON.

After the Tragedy, the favourite Ballet of

Little Red Riding Hood.

Lubin, Miss C. DURANG. Wolfe, (the Robber) Mr. C. DURANG. Old Man, Mr. MURRAY.
Villagers, Messrs. SCRIVENER, MARTIN, PARKER, &c. Grand Mother, Mr. CARTER.
Red Riding Hood, Miss E. DURANG. Anna, Miss SEYMOUR. Janet, Mrs. CARTER.
Ellen, Mrs. RICHARDSON. Phœbe, Miss BATHWELL. Colinette, Mrs. BLOXTON.

In the course of the Ballet the favourite Dances to the Airs of

Paddy O'Rafferty, Coolin, &c. &c.

To conclude with

A GENERAL DANCE.

To which will be added the favourite Farce of the

Budget of Blunders.

Mr. Growley, Mr. HERBERT. Doctor Dablancour, Mr. BLISSETT.
Doctor Snugface, Mr. JEFFERSON. Captain Belgrave, Mr. BAKER. Tom, Mr. CARTER.
Servant to Dablancour, Mr. PARKER. Post Boy, Mr. MARTIN.
Sophy, Miss SEYMOUR. Bridget, Mrs. FRANCIS. Deborah, Mrs. BLOXTON.

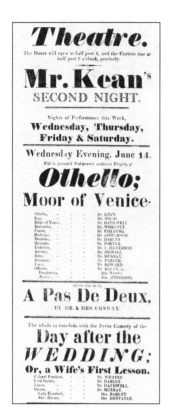

In 1821, Edmund Kean appeared in *Othello* (left). At the time, the theater had a resident company that would provide the supporting cast for a star's appearance. Edwin Forrest also appeared as Othello (below) with the same supporting company.

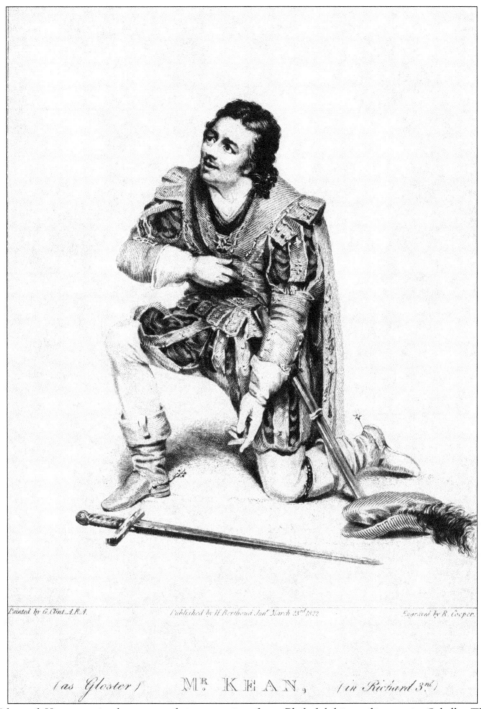

(as Gloster) M.ʳ KEAN, *(in Richard 3.ʳᵈ)*

Edmund Kean received a tremendous reception from Philadelphia audiences in *Othello, The Merchant of Venice,* and *Richard III* (above). His appearance introduced the custom of bringing out the actor for a curtain call, a practice that the theater's manager found ludicrous. Today the curtain call is standard practice, but it was first introduced to American audiences at the Walnut Street Theatre. (Courtesy of the Theatre Collection, Free Library of Philadelphia.)

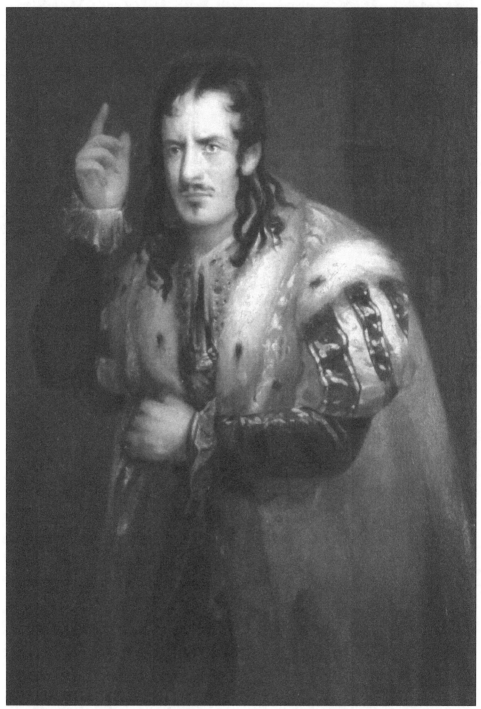

A virtual unknown when he came to America in 1821, Junius Brutus Booth first appeared at the Walnut and quickly established himself as a favorite with American audiences. Booth bore a resemblance to Edmund Kean, and he suffered from the comparison, often accused of simply being an imitator of Kean. He was the father of the famous acting family that included three sons, Junius Jr., Edwin, and John Wilkes, and a daughter, Asia.

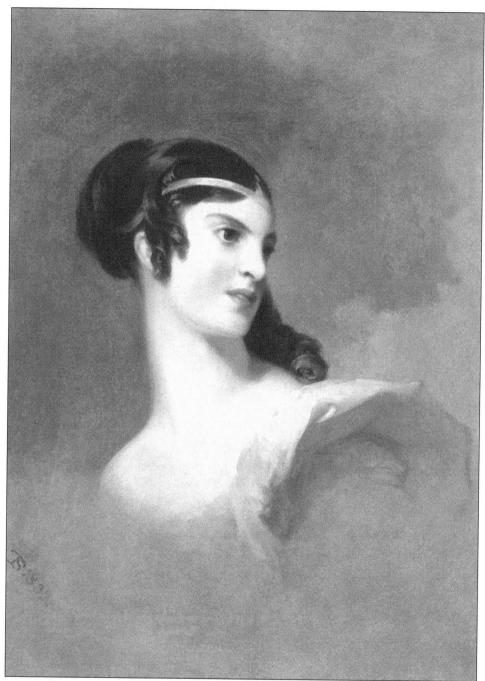

Fanny Kemble, member of a prestigious British acting family, arrived in America in 1832. She captured the hearts of the American public and instantly became a major star. She was courted by the rich Philadelphia slave owner Pierce Butler, whom she subsequently married at Christ Church. Shortly thereafter, she retired from the stage. Their eventual divorce trial became one of the first major celebrity tabloid stories in America. This painting of Kemble as Julia in Sheridan Knowles's *The Hunchback* by the renowned Philadelphia artist Thomas Sully was painted in 1833. (Courtesy of the Rosenbach Museum and Library.)

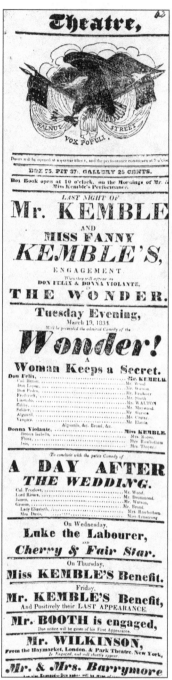

Fanny Kemble appeared with her father on the night of March 19, 1833, in the comedies *Wonder! A Woman Keeps a Secret* and *A Day after the Wedding*. Also shown on the handbill for this performance are upcoming benefit performances that, at the time, were an actor's means of generating what would today be called an annuity. Upcoming engagements featuring Junius Brutus Booth and Maurice and Georgianna Barrymore are also listed. Incidentally, Kemble also played Juliet with her father playing her love interest, Romeo. (Courtesy of the Theatre Collection, Free Library of Philadelphia.)

After becoming popular on the English stage, Irish comedians began to perform in America. The most renowned of these was Tyrone Power, the great-grandfather of the Hollywood star. He made his debut in September 1833 in *The Irish Ambassador* and *The Irish Tutor*. He became a favorite with American audiences and returned for two more engagements. Sadly, on his return to England in 1841, the ship he was sailing on was lost at sea. (Courtesy of the Theatre Collection, Free Library of Philadelphia.)

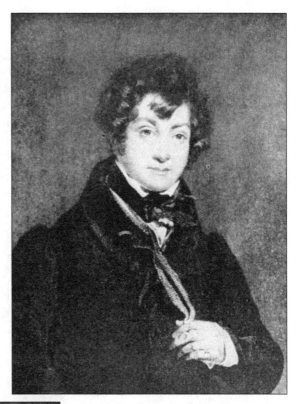

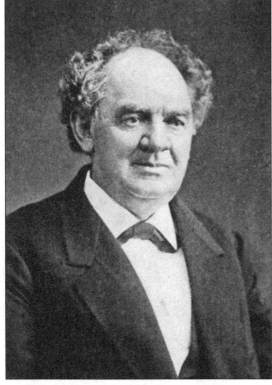

In January 1836, a juggler named Signor Vivalla was booked for a week. More notable was his manager, 25-year-old P. T. Barnum (left), who was beginning his career as a showman. Barnum demonstrated his flair for generating publicity when he promoted a rivalry between Vivalla and a local juggler, issuing a $1,000 challenge to anyone who could duplicate Vivalla's tricks. The competition was a huge success and went on to be repeated in other cities. (Courtesy of the Theatre Collection, Free Library of Philadelphia.)

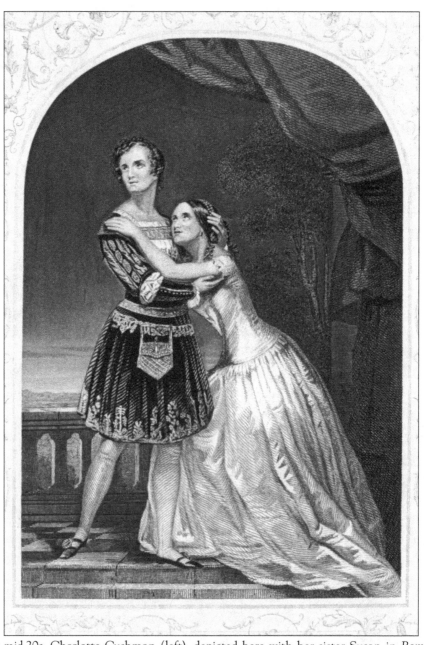

By her mid-20s, Charlotte Cushman (left), depicted here with her sister Susan in *Romeo and Juliet*, was heralded as one of the finest actors America had ever produced. She was also one of the first female stage managers, today known as stage directors. Tall and ruggedly built with a pronounced jaw, wide-set eyes, and angular features, she was not a traditional leading lady. She became renowned for playing male characters, as there were a limited number of great dramatic roles for women. In Cushman's case, however, breeches (male) roles suited her better, with her most famous role being Romeo. In 1843, Charlotte Cushman became the first female manager of the Walnut. She also continued to be one of America's leading actresses and was a pioneer in protecting actresses, who were considered "loose women" at the time, from being taken advantage of by men. (Courtesy of the Theatre Collection, Free Library of Philadelphia.)

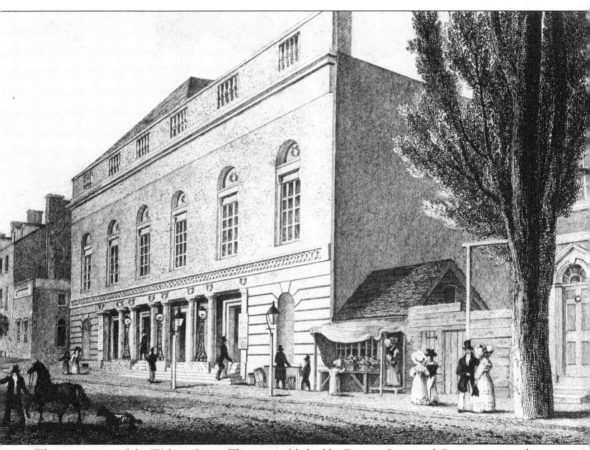

This engraving of the Walnut Street Theatre, published by Fenner, Sears and Company around 1840–1845, was modeled after an 1831 drawing by Charles Burton. This image depicts the building after a major renovation was conducted in 1828, designed by famed Philadelphia architect John Haviland. Today's restored facade is based on this design. (Courtesy of the Library of Congress, Prints and Photographs Division.)

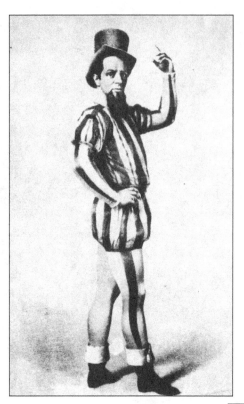

In November 1843, Dan Rice, who was known for his "popular comicalities," appeared at the Walnut. He went on to be known as America's first great circus clown and the model for Uncle Sam. (Courtesy of the Theatre Collection, Free Library of Philadelphia.)

In December 1848, Charles S. Stratton, better known as "General Tom Thumb" (left), pictured here with his wife, appeared on the Walnut's stage. This protégé of P. T. Barnum stood only 25 inches tall and weighed 15 pounds. He was 11 years old when he appeared in a farce written especially for him, but Barnum announced his age as 18. (Courtesy of the Theatre Collection, Free Library of Philadelphia.)

Two

FROM 1850 TO 1899

Some of the greatest American actors of the mid- to late 19th century made their mark on the stage portraying William Shakespeare's colorful characters. Clockwise from the top left are William Warren as Lance in *Two Gentleman of Verona*, Laura Keane as Portia in *The Merchant of Venice*, James Hackett as Falstaff in *King Henry IV*, and Henry Placide as Polonius in *Hamlet*. These drawings were created for the first complete American printing of Shakespeare's works.

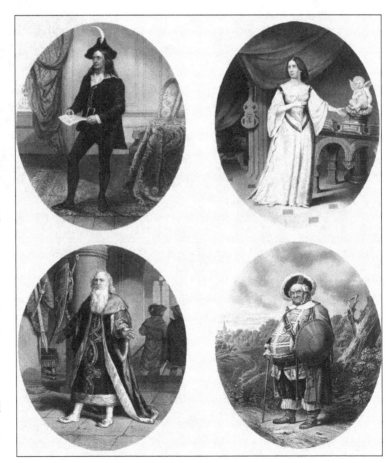

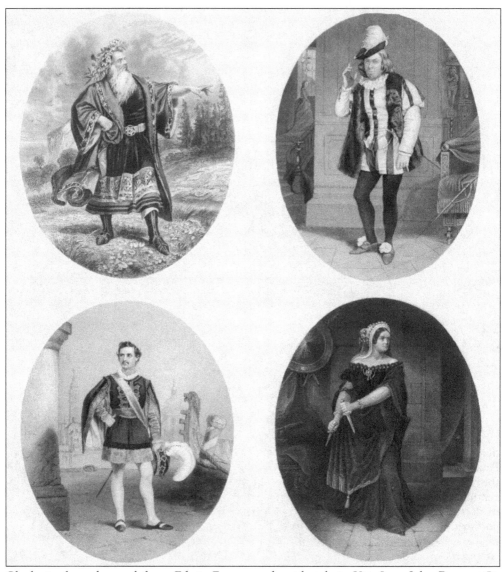

Clockwise from the top left are Edwin Forrest as the title role in *King Lear*, John Drew as Sir Andrew Ague-Cheek in *Twelfth Night*, Charlotte Cushman as Lady Macbeth in *Macbeth*, and Edwin Booth as Iago in *Othello*. These drawings were created for the first complete American printing of William Shakespeare's works.

Opening in January 1852 in *Betley, the Tyrolean* and *Un Jour de Carnival de Seville*, Lola Montez played two weeks at the Walnut. Both were pieces designed to highlight her dancing. Although a beauty and skilled performer, Montez was notorious for her offstage exploits, which included a celebrated affair with the king of Bavaria. Montez returned to the Walnut in May of that year to make her acting debut in *Lola Montez in Bavaria*, which attempted to tell the love story of her affair.

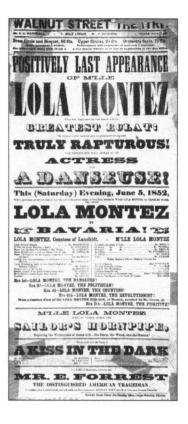

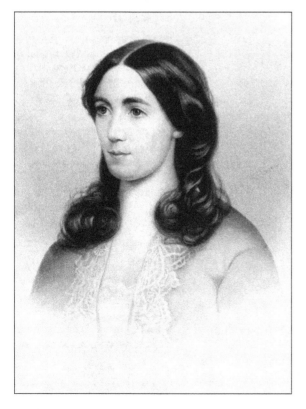

Philadelphia actress Matilda Heron opened the 1855–1856 season playing the title role of *Camille*. Heron's version was a new translation of the play based on *La Dame aux Camelias*, which she had seen in Paris. This was written in a more realistic approach than previous versions, allowing Heron to show her full range of emotional style, and went over very well with audiences. (Courtesy of the Theatre Collection, Free Library of Philadelphia.)

The 1854–1855 season included the debut of one of the most influential playwrights of the 19th century, Dion Boucicault. At the time of his Walnut debut, he was largely unknown and came as the manager of his wife Agnes Robertson's tour. Robertson was the adopted daughter of Charles Kean (son of actor Edmund Kean). Boucicault went on to write or adapt over 130 stage plays, including the antislavery play *The Octoroon* and Joseph Jefferson's *Rip Van Winkle*. He was also a key force in establishing dramatic copyright laws in America. (Courtesy of the Theatre Collection, Free Library of Philadelphia.)

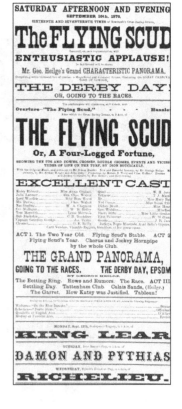

Dion Boucicault is viewed as an innovator in his use of the stage to keep the action moving. In *Flying Scud*, he managed to achieve the effect of a live horse race onstage.

Renowned French actress Rachel made her only appearance at the Walnut Street Theatre in November 1855 in *Les Horaces*. The actress, known as the greatest tragedienne in France, was often compared to Edmund Kean. Her tour was scheduled to play a week at the Walnut, but when freezing weather set in on the first night, Rachel's brother, the tour's manager, refused to pay the costs of heating the backstage area, and Rachel was taken ill. She was unable to continue with the production, and houses were thin and ticket prices were lowered as the show went on without its star. Soon after, the pneumonia she contracted at the Walnut developed into tuberculosis, and the great actress was dead within three years. (Courtesy of the Theatre Collection, Free Library of Philadelphia.)

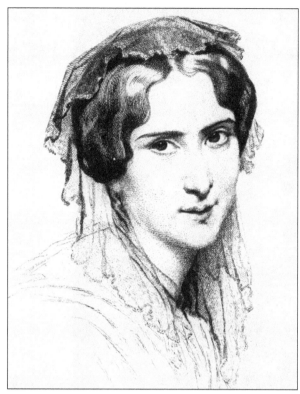

Laura Keene made her Philadelphia debut when she opened at the Walnut in October 1856. Keene was the first American woman to operate her own theater, and while her new space was being built on Broadway, she took her company on the road to present a repertoire of classic comedies and recent melodramas. Of note, she was starring in *Our American Cousin* at Ford's Theatre the night Abraham Lincoln was shot. (Courtesy of the Theatre Collection, Free Library of Philadelphia.)

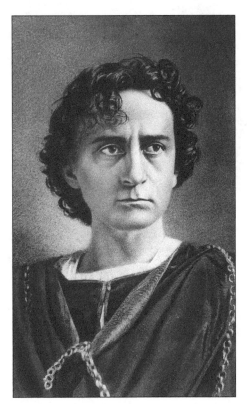

Edwin Booth, son of renowned actor Junius Brutus Booth, made his Walnut debut in June 1857. Among his roles in that two-week period, he performed three tragic parts identified with his father—Othello, Richard III, and King Lear. Still a young actor, he suffered by comparison to the established Junius.

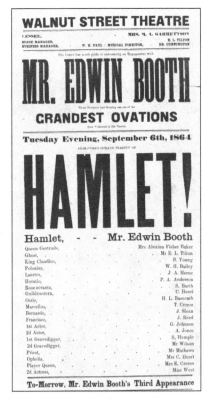

Sometimes called the "Hamlet of the 19th century," Edwin Booth went on to become one of America's greatest and most influential stage actors. He developed a quiet and subtle acting style, suitable for his signature role of Hamlet and other Shakespearian tragedies.

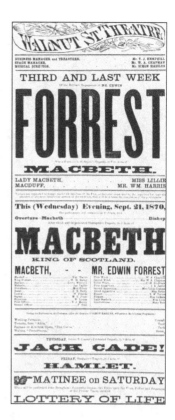

On October 4, 1851, Edwin Forrest opened a three-week run of *Macbeth*. It was the actor's first appearance in Philadelphia in two years, and he was in the middle of a highly publicized divorce from his wife at the time. Forrest performed to sold-out houses for the entire run, and hundreds of people had to be turned away. This photograph was taken by Mathew B. Brady, noted portrait and Civil War photographer. (Below, courtesy of the Lillian Booth Actors' Home of the Actors Fund.)

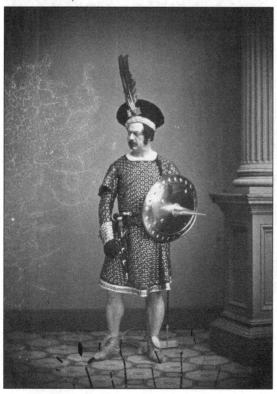

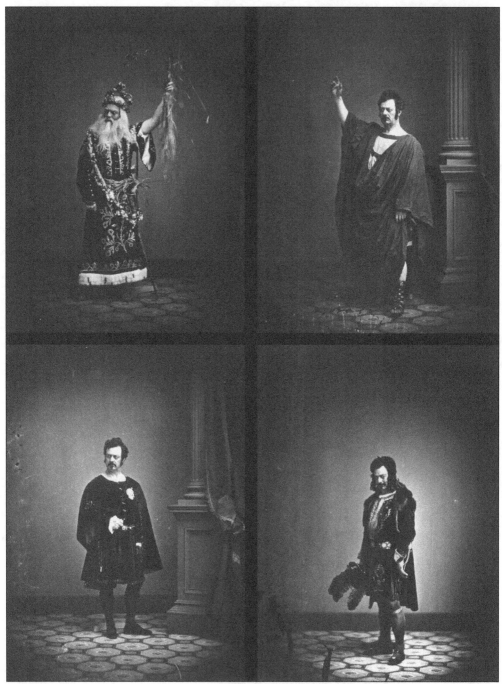

Mathew B. Brady, noted portrait and Civil War photographer, captured Edwin Forrest in some of his most notable roles in a photo shoot around 1861. Clockwise from the top left, he is seen as King Lear, Brutus, Richard III, and Hamlet. (Courtesy of the Lillian Booth Actors' Home of the Actors Fund.)

In December 1857, Mrs. D. B. Bowers, a former member of the Walnut's stock company, took over management of the theater. The Walnut was dark for a week as she had the space cleaned and installed new seats in the orchestra to accommodate ladies' hoopskirts. Bowers was intent on reintroducing the stock system at the Walnut, and she collected a talented group of actors to make up the company, including John and Louisa Lane Drew. Despite the quality of productions, the economy was poor, and Bowers failed to contain production costs. In January 1859, she relinquished control of the Walnut.

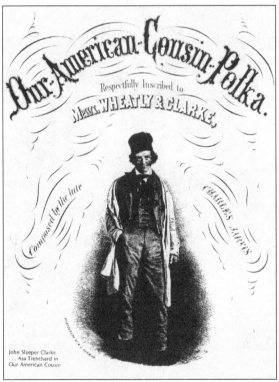

John Sleeper Clarke
. . . Asa Trenchard in
Our American Cousin

John Sleeper Clarke was a comic actor already well known in Philadelphia when he made his first appearance at the Walnut in August 1861 in *Paul Pry*. Clarke was closely tied to the Booth family, as the husband of Asia Booth and boyhood friend of Edwin. In 1863, Clarke and Edwin Booth teamed up to manage the Walnut. They were successful both financially and creatively, and the following year, they took over the lease of the Winter Garden Theatre in New York. Following the assassination of Pres. Abraham Lincoln by Clarke's brother-in-law John Wilkes Booth, Clarke was imprisoned under suspicion of his role as a coconspirator but was released due to lack of evidence. In this image (left), Clarke is shown on the cover of "*Our American Cousin Polka*," sheet music written for the play Lincoln was attending the evening he was shot. (Courtesy of the Theatre Collection, Free Library of Philadelphia.)

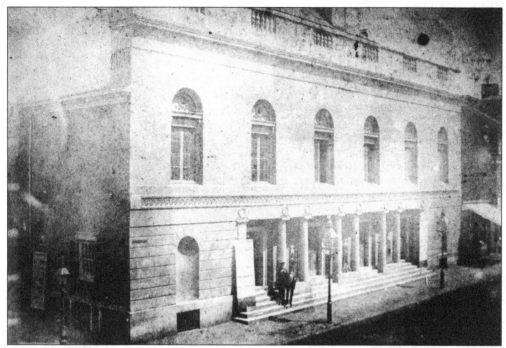

Edwin Booth and his brother-in-law John Sleeper Clarke carried out extensive renovations. This 1865 image is the earliest-known photograph of the Walnut. (Courtesy of the Library of Congress, Prints and Photographs Division.)

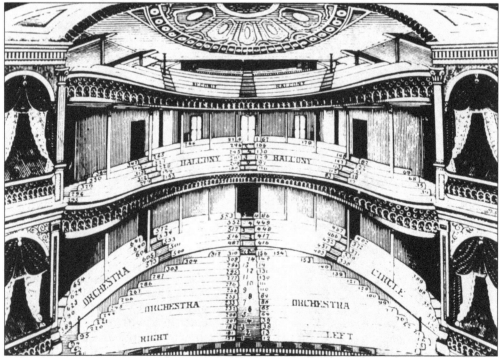

This c. 1865 image is of the renovated interior. This interior was duplicated and used for construction of the Springer Opera House in Columbus, Georgia, where it still stands today.

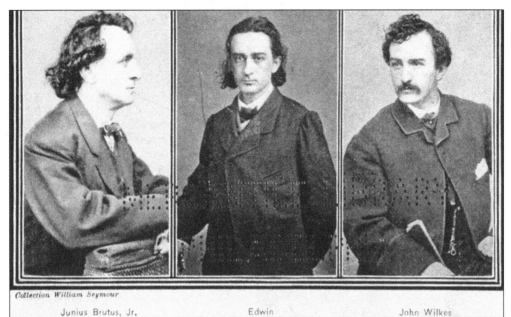

Junius Brutus, Jr. Edwin John Wilkes

From left to right are the three sons of Junius Brutus Booth: Junius Brutus Jr., Edwin, and John Wilkes. While all were known in the mid-1800s for their acting abilities, the name John Wilkes Booth became infamous on April 15, 1865, as Abraham Lincoln's assassin. The assassination provoked strong public reactions against the theatrical profession and the Booth family. Junius Brutus Jr. and his brother-in-law John Sleeper Clarke were arrested and jailed. Edwin Booth remained free but announced his retirement from the stage. (Courtesy of the Theatre Collection, Free Library of Philadelphia.)

The handwritten note across the top of this advertisement from April 14, 1865, reads, "No performance in consequence of death of A. Lincoln." The Walnut closed the next day and remained dark through the following week. Members of the theatrical profession drafted resolutions expressing regret that a fellow actor had been responsible for the shooting. They also gathered as a group at Independence Hall when Lincoln's remains were brought to Philadelphia as part of the funeral procession.

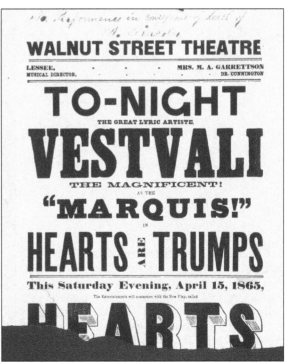

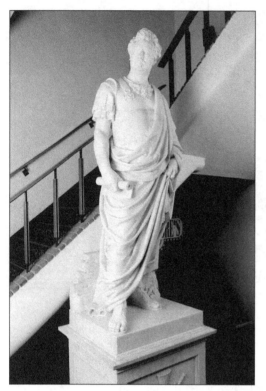

In November 1860, Edwin Forrest returned to the Walnut for the first time in over 10 years. He performed a different Shakespearian play every night so the public could see all his roles. Although the theater sold out each night, Forrest's age and physical decline were evident and his bold, exaggerated acting style was viewed as old-fashioned. Regardless, Forrest still had a large following. A number of his admirers commissioned a full-length statue of the actor in the role of Coriolanus by sculptor Thomas Ball. Forrest was so impressed with the piece that he purchased it and moved it to his home in Philadelphia, where it resided until 1985 when it was given to the Pennsylvania Historical Society. In 1999, the statue was acquired by the Walnut Street Theatre and now stands on a pedestal in the theater's lobby with Forrest facing the stage.

Lotta Crabtree made her debut at the Walnut in August 1873, appearing in *The Little Detective*. A performer of the variety tradition, Crabtree was known for her strong acting and musical ability, playing roles that allowed her to assume many disguises to show off her versatility. (Courtesy of the Theatre Collection, Free Library of Philadelphia.)

Buffalo Bill Cody was the biggest hit of the 1879–1880 season when he appeared in *The Knight of the Plains; or, Buffalo Bill's Best Trail* in February 1880. The recent publication of his autobiography sparked interest in this colorful showman, and crowds rushed to see him perform. Cody returned to the Walnut the following season, but in the summer of 1883, he organized an outdoor show to present extravaganzas that combined elements of the stage play with the circus and other theatrical pieces. This proved so successful that he gave up his indoor stage career and toured with his Wild West show for 30 years. (Right, courtesy of the Theatre Collection, Free Library of Philadelphia.)

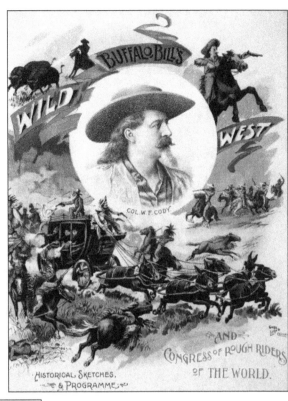

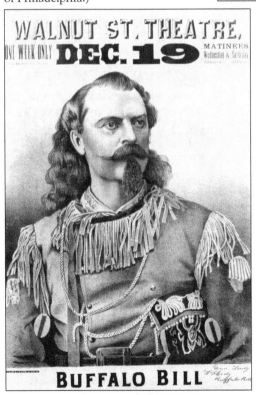

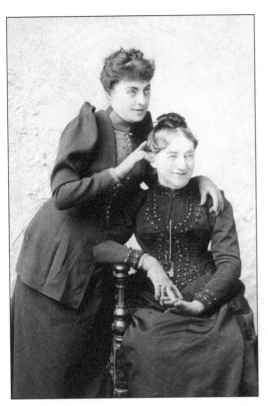

In the photograph at left, Georgianna Emma Drew Barrymore stands behind her mother, Louisa Lane Drew. Georgianna was a noted actress and mother to Lionel, John, and Ethel Barrymore. Louisa was also an actress and manager of Philadelphia's Arch Street Theatre. The handbill advertises a benefit in honor of Mrs. John Drew held at the Walnut. (Left, courtesy of the Theatre Collection, Free Library of Philadelphia.)

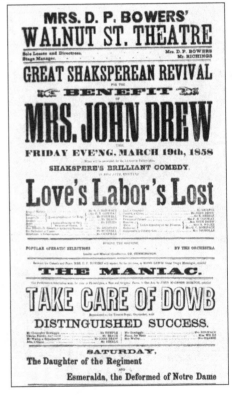

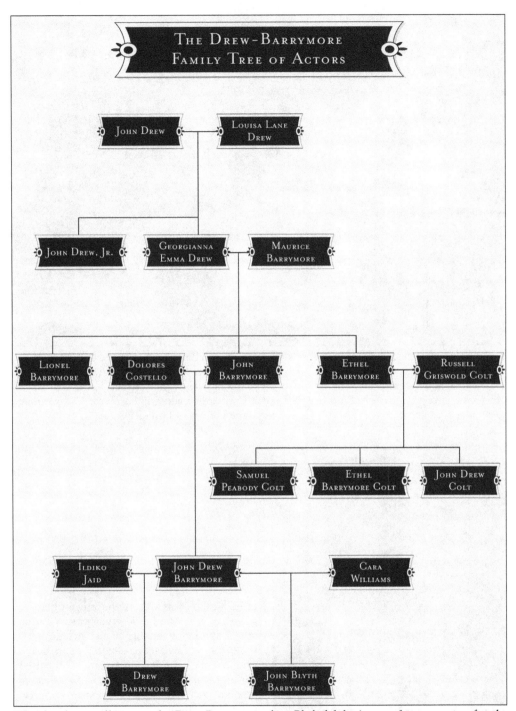

This family tree illustrates the Drew-Barrymore clan, Philadelphia's most famous acting family. Although there are many more spouses, siblings, and children who do not appear in this diagram, it highlights the members of the family with the most notable acting careers. (Courtesy of John Hennessy.)

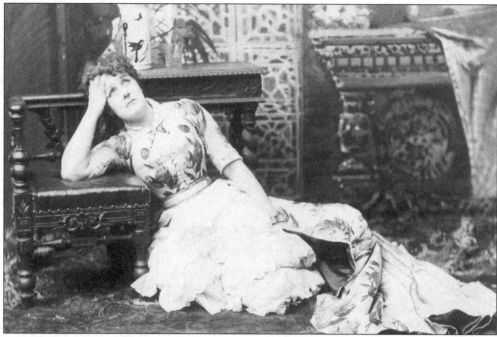

Fanny Davenport modeled herself after French actress Sarah Bernhardt, inspired by her passionate acting style and glamorous lifestyle. Davenport even began to secure the rights to Bernhardt's vehicles. The first was *Fedora*, in which she appeared at the Walnut Street Theatre in March 1884. She later acquired several other Bernhardt standards, including *La Tosca*, *Cleopatra*, and *Gismonda*. (Courtesy of the Theatre Collection, Free Library of Philadelphia.)

Lillie Langtry was known not only for her stage career but for her legendary beauty, social status, and many notable lovers, including the Prince of Wales. She is noted as an early example of celebrity endorsement, as she used her high public profile to sponsor commercial products such as cosmetics and soap. Langtry made her Walnut debut in January 1887 in *A Wife's Peril* and performed a second week in *The Lady of Lyons*. She appeared the following year in *As in a Looking Glass*, playing opposite Maurice Barrymore. (Courtesy of the Theatre Collection, Free Library of Philadelphia.)

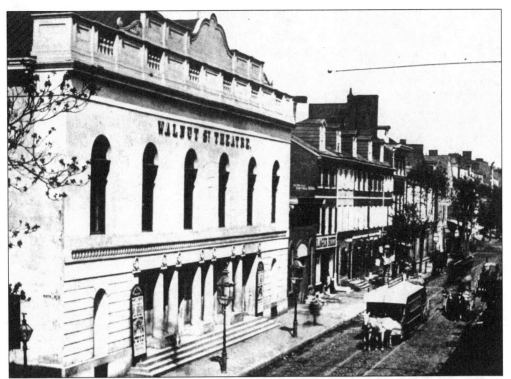

The Walnut Street Theatre is pictured around 1885. This image also shows a horse-drawn trolley, which was an early form of public transportation. (Courtesy of the Library of Congress, Prints and Photographs Division.)

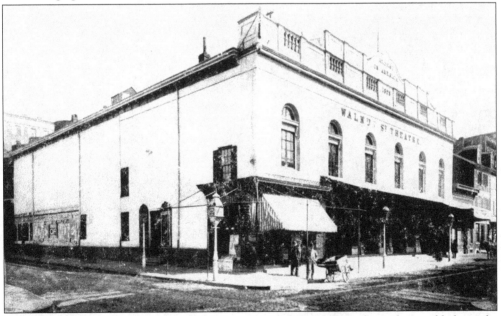

The Walnut Street Theatre is seen here around 1890. A small retail stand was added to take advantage of the busy corner at Ninth and Walnut Streets. (Courtesy of the Library of Congress, Prints and Photographs Division.)

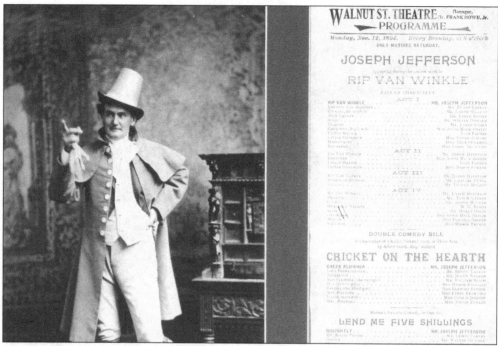

Philadelphia native Joseph Jefferson was an actor and one of the most famous American comedians of his time. His most successful role was the title character in Dion Boucicault's version of *Rip Van Winkle*, which he played for over 40 years. Jefferson brought this production to the Walnut in 1892. His name is still significant in the theater scene today through the Joseph Jefferson Awards in Chicago. He is also credited as the source of sage words of advice to all performers, having said, "There are no small parts, only small actors."

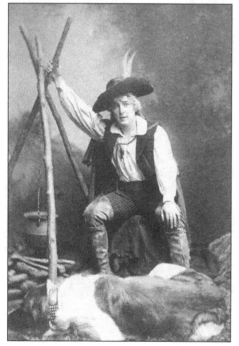

In January 1893, Irish tenor Chauncey Olcott made his debut at the Walnut Street Theatre in Augustus Pitou's Irish drama *Mavourneen*. Olcott was so successful in his role that he appeared regularly at the Walnut for over 20 years. He is known for writing some of the most familiar Irish melodies, including "My Wild Irish Rose" and "Mother Machree." Olcott also popularized "When Irish Eyes Are Smiling" in a 1913 production of *The Isle of Dreams*.

Lionel Barrymore, eldest son of famous actors Maurice Barrymore and Georgianna Emma Drew Barrymore and brother of Ethel and John, made his Walnut debut in February 1898. He appeared in *Cumberland '61*, a Civil War drama. Lionel would go on to a very successful stage and screen career. An Academy Award–winning actor and an Academy Award–nominated director, his best-known role is that of Mr. Potter in the Christmas favorite *It's a Wonderful Life*. (Courtesy of the Theatre Collection, Free Library of Philadelphia.)

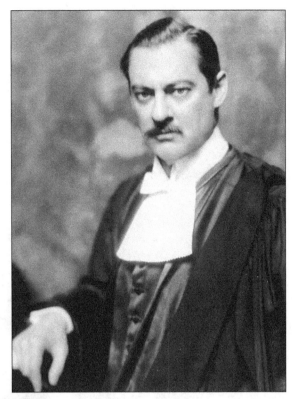

James O'Neill, father of playwright Eugene O'Neill, made his debut with a two-week appearance at the Walnut in September 1899. O'Neill starred in two Alexandre Dumas plays. The first week, he played D'Artagnan in *The Three Musketeers*, and the second week, he played his most famous role, Edmund Dantes in *The Count of Monte Cristo*. (Courtesy of the Theatre Collection, Free Library of Philadelphia.)

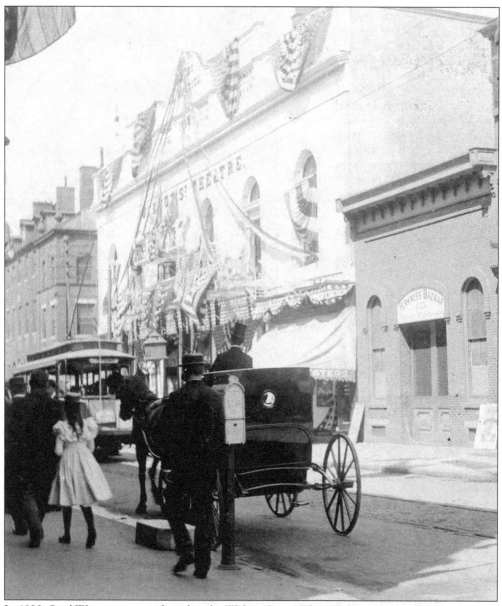

In 1899, Civil War veterans gathered at the Walnut Street Theatre for a reunion. In true patriotic fashion for the occasion, the building was outfitted with red, white, and blue bunting.

Three

FROM 1900 TO 1940

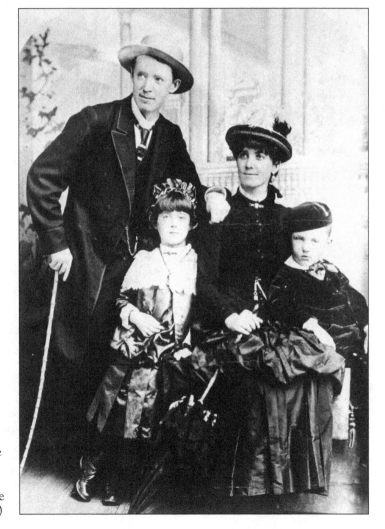

Although the summer of 1900 was the only time that vaudeville was attempted at the Walnut, several leading vaudevillians appeared at the theater in legitimate productions. Most notably were the Four Cohans, who opened *The Governor's Son* in April 1901. While the production was only moderately successful, it allowed 22-year-old George M. Cohan (left) to make the leap from vaudeville to legitimate theater. (Courtesy of the Theatre Collection, Free Library of Philadelphia.)

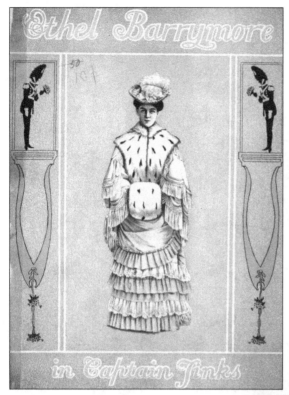

At age 21, the lovely Ethel Barrymore made her Walnut Street Theatre debut in *Captain Jinks of the Horse Marines*. This member of the highly acclaimed Barrymore family would go on to become one of America's most renowned theater actresses of her time. However, her success as an actress was not immediately clear following the opening night at the Walnut in January 1901. Her nervousness was evident to the crowd that evening, and a voice called out from the gallery, "Speak up, Ethel! All the Drews are good actors!" Despite an unsuccessful run in Philadelphia, the show went on to New York where Ethel overcame her shyness and became the toast of Broadway during her six-month run. (Courtesy of the Theatre Collection, Free Library of Philadelphia.)

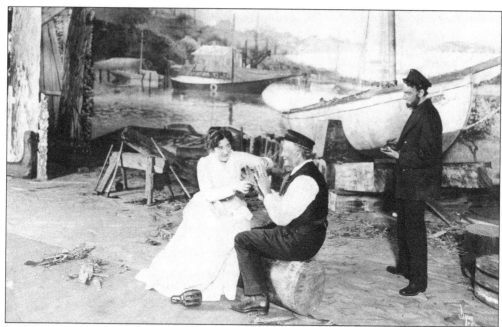

In February 1901, James A. Herne (center) returned to the Walnut, where he had once worked as a stock actor. The actor and playwright played father to his real-life daughter in this production of *Sag Harbor*. Sadly, this would be his last run at the Walnut. Herne was not well and withdrew from the show during its run in Chicago. He died at his home a few weeks later. The other actors in the photograph are not identified.

The 1902 season opened with *The Wild Rose*, starring a young showgirl named Evelyn Nesbit. Despite her notoriety as a model and Gibson girl, Nesbit is best known for her involvement in what would later be called the "crime of the century" when her husband, Harry K. Thaw, murdered her former lover, prominent architect Stanford White, on the rooftop garden of Madison Square Garden. Their story was later sensationalized in the 1955 film *The Girl in the Red Velvet Swing*. Also of note, prior to her marriage to Thaw, Nesbit was courted by John Barrymore, member of the famous Barrymore acting clan. Despite becoming pregnant by Barrymore twice, she turned down his marriage proposals. (Courtesy of Hulton Archive/Stringer/Getty Images.)

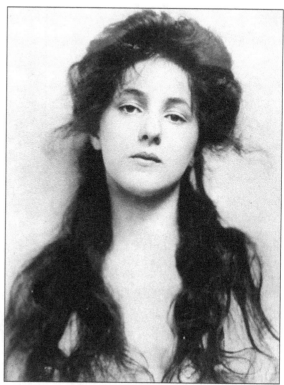

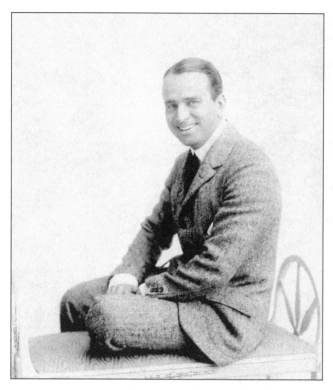

In 1903, Douglas Fairbanks made his Walnut Street Theatre debut in a supporting role in *The Pit*. Fairbanks would return two more times to the Walnut, starring in *The Man of the Hour* and supporting Thomas Wise in *A Gentleman from Mississippi*. Fairbanks soon after made the crossover into the movie business, where he went on to help form United Artists Studios and married "America's Sweetheart," movie star Mary Pickford. This was Hollywood's first major celebrity marriage. (Courtesy of the Theatre Collection, Free Library of Philadelphia.)

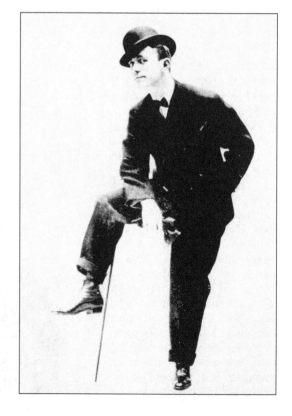

In October 1904, George M. Cohan brought his new musical *Little Johnny Jones* to the Walnut on its way to Broadway. The 26-year-old Cohan was both the star and creator of this production, his first full-length musical. The breakthrough leading role was inspired by real-life hall of fame jockey Tod Sloan, and the show introduced two timeless musical numbers—"Give My Regards to Broadway" and "I'm a Yankee Doodle Dandy." (Courtesy of the Theatre Collection, Free Library of Philadelphia.)

In October 1907, Will Rogers made
a brief venture out of vaudeville
and into legitimate theater when
he performed his rope-spinning act
between the acts of *The Girl Rangers*.
A legend in Wild West shows and
vaudeville, Rogers was as popular
with audiences for his expert rope
skills as he was for his wisecracks
and folksy observations. Famed
cowboy and humorist Rogers starred
on Broadway and in 71 movies,
wrote six books and more than
4,000 syndicated newspaper columns,
and was America's first big-time radio
commentator. (Courtesy of Hulton
Archive/Stringer/Getty Images.)

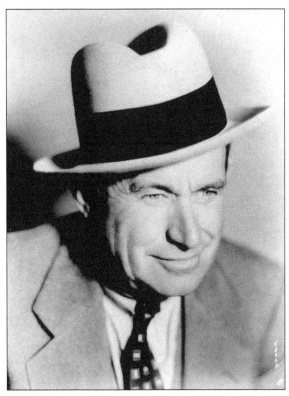

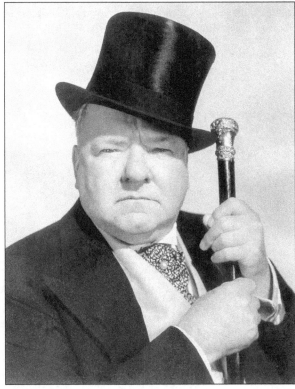

The blackface team of McIntyre
and Heath came to the Walnut
in *The Ham Tree* in January 1908.
This musical adventure of two
African Americans stranded
in a small town featured W. C.
Fields in a supporting role as a
tramp juggler. Fields went on to
achieve international acclaim as a
world-class juggler, taking his tramp
character to several continents and
to Broadway in the Ziegfeld Follies.
(Courtesy of Hulton Archive/
Stringer/Getty Images.)

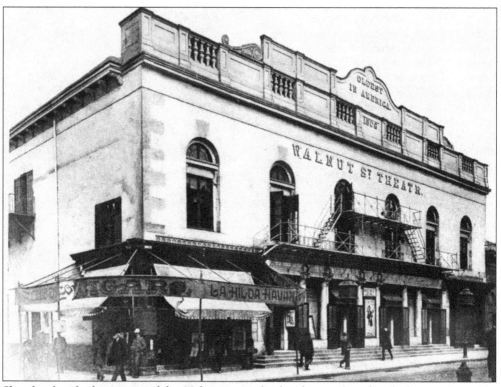

Shortly after the beginning of the 20th century, the facade was altered with the erection of an exterior fire escape and the installation of vestibules between each set of columns. (Courtesy of the Library of Congress, Prints and Photographs Division.)

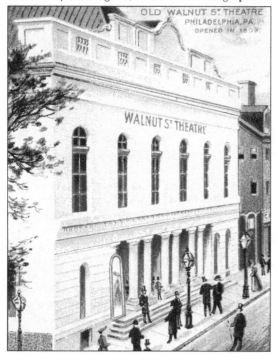

The Walnut Street Theatre's facade is shown as depicted on a souvenir card issued by Between the Acts Cigars around 1910.

Beginning her career performing in burlesque and vaudeville numbers, singer and comedian Sophie Tucker became one of the most popular entertainers in America during the early 20th century. In 1912, she had success in a supporting role at the Walnut in *Louisiana Lou*, and she reportedly brought down the house with a spoof of underworld dancing known as "the Puritan Prance." (Courtesy of the Theatre Collection, Free Library of Philadelphia.)

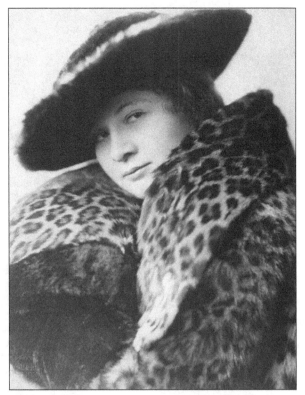

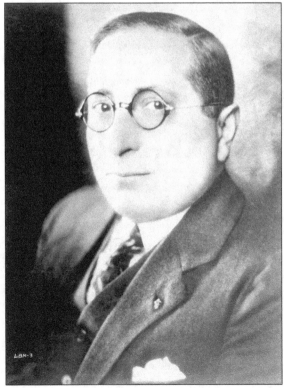

At age 28, Louis B. Mayer (left) and his partner Ben Stern purchased the Walnut. The pair's plan was to produce touring shows and use the theater as a starting point for its productions. When they purchased the lease in 1913, however, they discovered the Walnut needed extensive repairs, and there was a rumor it might be demolished. Mayer and Stern eventually spent $6,000 in repairs, and the season opened in August 1913 with *The Firefly*. Their method of one- and two-week bookings of plays that had previously debuted on Broadway was successful, although after one year their partnership ended, and Mayer went on to Hollywood where he formed the production company that would ultimately become Metro-Goldwyn-Mayer. (Courtesy of Hulton Archive, Getty Images.)

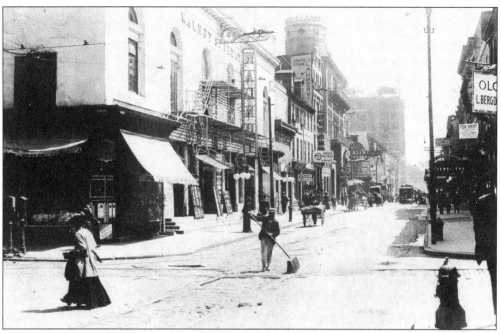

The Walnut Street Theatre exterior as it appeared around 1913 is seen here. The castle tower in the background is part of the Casino Theatre, and beyond it, one can view the Curtis Center under construction. (Courtesy of the Library of Congress, Prints and Photographs Division.)

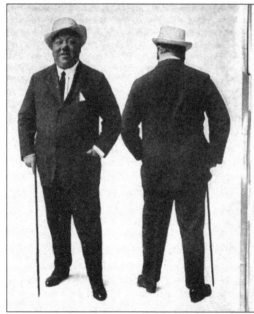

AN EVENT OF INTERNATIONAL
INTEREST

In response to the thousands of my admirers all over the world, I have made special arrangement with the Vitagraph Company of America for a limited leave of absence and am therefore enabled to announce a world's tour of myself. :: ::

John Bunny
TO APPEAR IN PERSON
with a company of sixty clever youngsters and some grown-ups, in the Musical Mixture

"Bunny in Funny Land"
DIRECTION WISWELL & SIDNEY

J. J. ROSENTHAL, Manager

John Bunny quit theater in 1910 to pursue a film career and went on to establish himself as the first comedy star in pictures. Returning to live theatrical performance, Bunny appeared at the Walnut in March 1915 in *Bunny in Funnyland*. Although the critics panned this combination minstrel, burlesque, and vaudeville show, audiences packed the house, anxious to see a film actor live and in the flesh. Unfortunately, the stress of a live tour ruined his health, and Bunny passed away the following month. (Courtesy of the Theatre Collection, Free Library of Philadelphia.)

In October 1915, Edward Everett
Horton led the Penn Players, the
Walnut Street Theatre's stock
company at the time, in several
productions, including *The Man
from Home, Within the Law,* and
Ready Money. Horton is best known
for his supporting roles in several
Fred Astaire–Ginger Rogers films
and went on to become the voice
of "Fractured Fairy Tales" on the
Rocky and Bullwinkle cartoon series.
(Courtesy of the Theatre Collection,
Free Library of Philadelphia.)

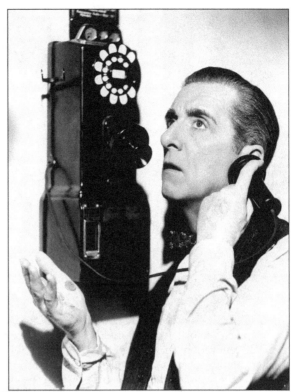

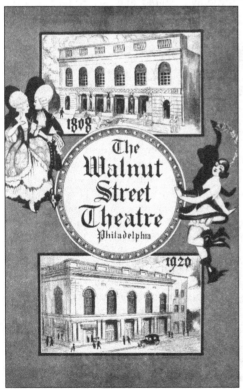

Pictured here is the cover of the Walnut Street
Theatre souvenir book *America's Oldest-Newest
Theatre,* published in December 1920 for the
opening after a major renovation supervised by
architect William H. Lee.

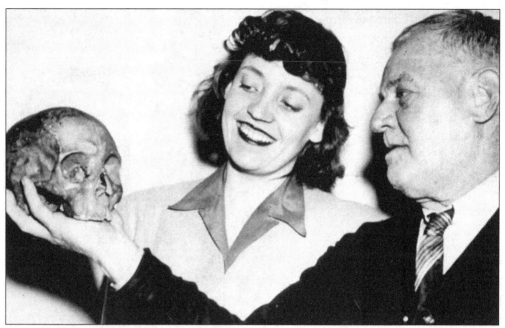

As workmen removed the old interior to build a new structure within the original walls for the 1920 renovation, they discovered a number of relics left behind from the early years of the theater. Among them was, carefully packed away, the skull of John "Pop" Reed, a stagehand who worked at the Walnut for more than 50 years in the first half of the 1800s. Reed stipulated in his will that he wanted his skull separated from his body, duly prepared, and used to represent the skull of Yorrick in *Hamlet*. His wish was granted, and the skull is signed by many famous actors of the day who performed in William Shakespeare's play.

A new play by influential English drama critic William Archer, *The Green Goddess* had its world premiere at the Walnut Street Theatre. The show was performed as part of the gala opening night of the newly renovated theater in December 1920. George Arliss (left) led the mostly British cast, and the play was a triumph for the actor. He went on to perform his role over 1,000 times and reprised it for the 1929 film, for which he received an Academy Award nomination. The play was so popular it even inspired Green Goddess salad dressing, created by a chef at the Palace Hotel in San Francisco.

In November 1921, the Provincetown Players presented Eugene O'Neill's *The Emperor Jones*. This landmark drama marked the first time an African American actor, Charles S. Gilpin, played the lead in a play produced by a white company.

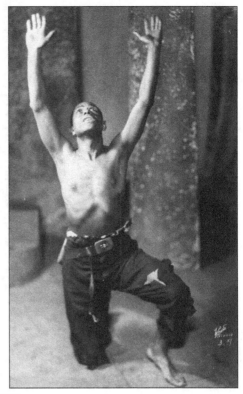

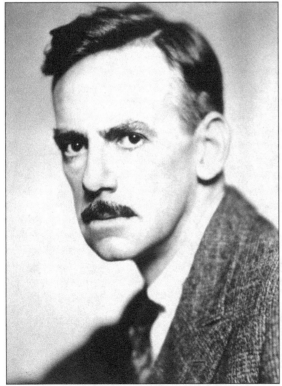

Son of Irish-born stage actor James O'Neill, Eugene O'Neill is viewed as one of the most renowned American playwrights of all time. He was the first American dramatist to introduce the concept of dramatic realism into American works and was the first to use true American vernacular in his speeches. In the early 1920s at the young age of 34, O'Neill had two landmark dramas play at the Walnut— *The Emperor Jones* and *Anna Christie*. (Courtesy of the Theatre Collection, Free Library of Philadelphia.)

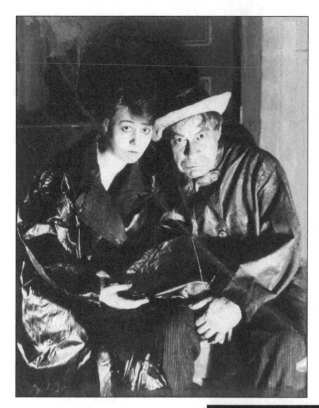

Eugene O'Neill's *Anna Christie* opened on Broadway in 1921 and won the Pulitzer Prize for drama that year. It tells the story of a former prostitute who falls in love but runs into difficulty in turning her life around. In December 1922, a touring production of the play came to the Walnut, starring Pauline Lord (left) and George Marion. Lord's performance as Anna was viewed as a triumph by the Philadelphia critics.

The Marx Brothers premiered their first show, *I'll Say She Is*, at the Walnut in June 1923. Although they were already established vaudeville stars, Harpo, Chico, Groucho, and Zeppo had never been in a legitimate show. The summer heat affected the audience turnout, but the show was a critical success. It played 13 weeks at the Walnut before embarking on a national tour. The Marx Brothers returned to the Walnut for three weeks prior to their New York opening, where their success established them as celebrities. (Courtesy of the Theatre Collection, Free Library of Philadelphia.)

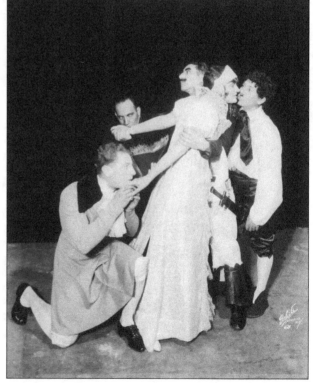

The 1920s featured a number of female playwrights who had success with comedies. Anita Loos, best known for her novel *Gentleman Prefer Blondes*, had her first success at the Walnut Street Theatre with *The Whole Town's Talking* in 1924. Loos is shown (right) with renowned American actress Helen Hayes. (Courtesy of the Theatre Collection, Free Library of Philadelphia.)

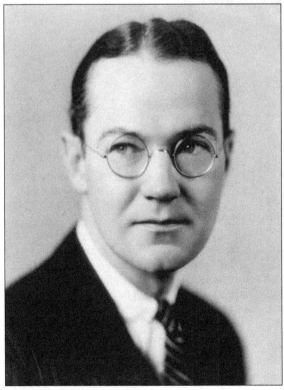

In the 1920s, comedy of manners had a revival in American playwrighting, reflecting the growing prosperity in the country. Philip Barry (left) was a hit with his comedy *You and I*, which played at the Walnut for two weeks in February 1924. The young playwright had written the play as a student at Harvard and received the Harvard Prize for his work. Barry is best known for his 1939 play *The Philadelphia Story*. (Courtesy of the Theatre Collection, Free Library of Philadelphia.)

In 1925, Imogene Coca had a supporting role in *When You Smile*, a musical adaptation of the 1923 play *Extra*. The show played the entire summer at the Walnut but flopped when it reached Broadway in the fall. This was Coca's first professional job, and the actress went on to have a successful Broadway theater and Emmy-winning television career. (Courtesy of the Theatre Collection, Free Library of Philadelphia.)

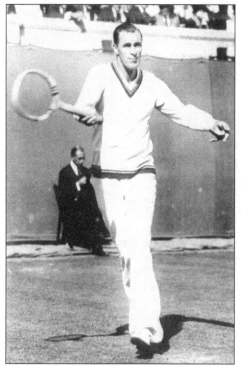

Tennis champion "Big Bill" Tilden starred at the Walnut in *They All Want Something* in 1926. Born a son of privilege on Philadelphia's Main Line on February 10, 1893, Tilden initially disliked tennis and even failed to make the college team on his first try. Known for his outward homosexuality and theatrical presentation on and off the court, he went on to become a shining light during sports' golden age in the 1920s. Although a thriving athlete, Tilden was a failed actor and novelist who lost much of his personal fortune backing Broadway plays that were far less successful than he was on the court. (Courtesy of the International Tennis Hall of Fame and Museum.)

Family comedies, the precursor to television sitcoms, made up most of the Walnut's 1926 season. Robert Montgomery had a supporting role in one such production called *One of the Family*. This and other family comedy tours that came through had little success, but Montgomery moved to Hollywood shortly thereafter and became a star. (Courtesy of the Theatre Collection, Free Library of Philadelphia.)

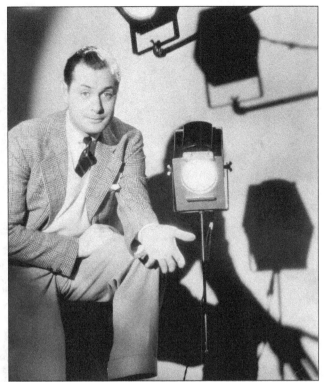

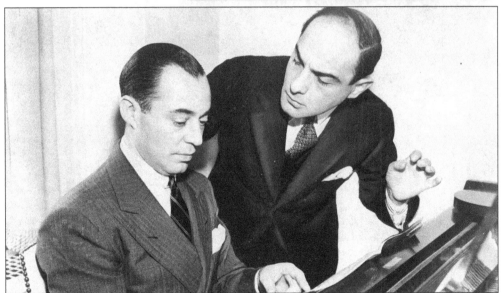

Richard Rogers (left) was only 24 and Lorenz Hart was 31 when the team paired up to create their first show. *Peggy Ann* appeared at the Walnut for a two-week pre-Broadway tryout in December 1926 and went on to run for almost a year on Broadway. The duo followed up with another success at the Walnut Street Theatre with *A Connecticut Yankee* in the fall of 1927. This production produced two Rogers and Hart standards, "Thou Swell" and "My Heart Stood Still," and ran for 418 performances on Broadway, becoming one of their most successful musicals. (Courtesy of the Library of Congress, Prints and Photographs Division.)

Known as "the First Lady of the American Theatre," Helen Hayes had a career that spanned 80 years. This American actress is one of only two women to have won an Emmy, Grammy, Oscar, and Tony Award. She has had several theaters named for her, including the current Helen Hayes Theatre, a Broadway house located on West 44th Street in Manhattan. In 1983, the Helen Hayes Awards were established in Washington, D.C., encouraging performers to reach for their goals as she did. Hayes made her first appearance at the Walnut in 1927. (Courtesy of the Theatre Collection, Free Library of Philadelphia.)

Helen Hayes made her Walnut debut as Maggie Wylie in a revival of James M. Barrie's *What Every Woman Knows* in January 1927. Hayes was a success, although she initially had doubts about her ability to perform the part, originated by Maude Adams, which Hayes viewed as a stretch for herself. She reprised the role in the 1934 film version of the same name.

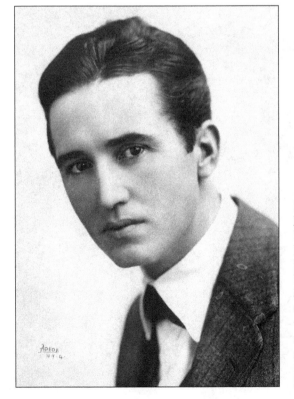

In 1929, the Walnut presented *Maggie the Magnificent* by Pulitzer Prize–winning playwright George Kelly. A member of the prominent Philadelphia Kelly family, George was brother to John, an Olympic rowing champion, and uncle to future Princess Grace of Monoco. Kelly got his start in vaudeville but went on to have success as a playwright with *The Show-Off* and *Craig's Wife*, among other plays. (Courtesy of the Theatre Collection, Free Library of Philadelphia.)

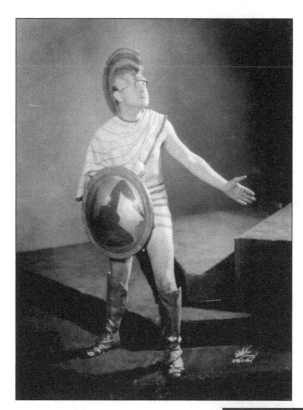

Ernest Truex in *Lysistrata* was the high point of the 1929–1930 Walnut Street Theatre season. This was the first production of the play in America. Truex is recognized as a great character actor of both stage and screen. He began his stage career as a child actor performing Shakespeare, where he was billed as "the Youngest Hamlet."

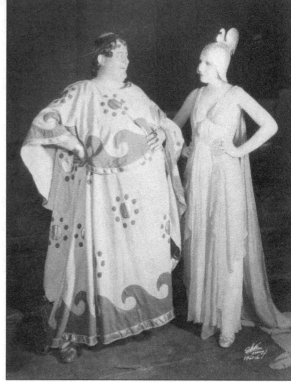

Sydney Greenstreet (left) and Violet Kemble-Cooper appeared in *Lysistrata*. Violet Kemble-Cooper, descendant of the famed Kemble acting clan, took over the title role for the final week of the Walnut's run.

Hope Emerson made her Broadway debut in *Lysistrata*, which tried out at the Walnut in April 1930 before moving to Broadway.

Hortense Alden (left) and Ernest Truex appeared in *Lysistrata*. For this production, the interior of the theater was transformed into a Greek temple.

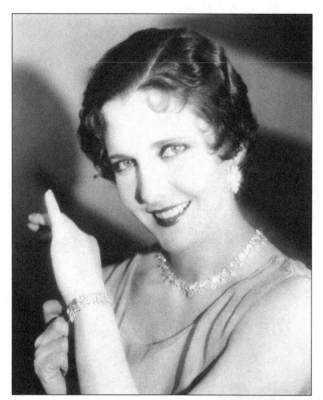

In August 1933, the Walnut was taken over by a group of producers that operated it as a pre-Broadway tryout house. The first season included film star Jean Arthur in *The Curtain Rises*. Called "the quintessential comedic leading lady" by Turner Classic Movies, Arthur is best known as the heroine in three Frank Capra films: *Mr. Deeds Goes to Town*, *You Can't Take It with You*, and *Mr. Smith Goes to Washington*. (Courtesy of the Theatre Collection, Free Library of Philadelphia.)

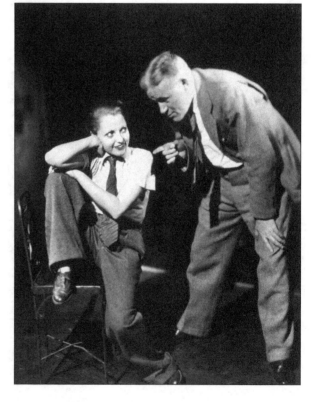

Opening the 1934–1935 season was Howard Lindsay's farce *She Loves Me Not*. The show, starring Polly Walters (left) and Charles D. Brown, had a successful run on Broadway the previous year. The production marked director Joshua Logan's professional debut. Logan went on to direct such memorable Broadway shows as *Annie Get Your Gun*, *Mister Roberts*, and *South Pacific*.

In the mid-1930s, the Walnut presented Yiddish theater. Maurice Schwartz, the leading producer of Yiddish drama and often called the "Yiddish Barrymore," appeared in *The Water Carrier* in the spring of 1937. Schwartz (left) is shown here in one of his signature roles, as the title character in *Hershel, the Jester* opposite Anna Appel.

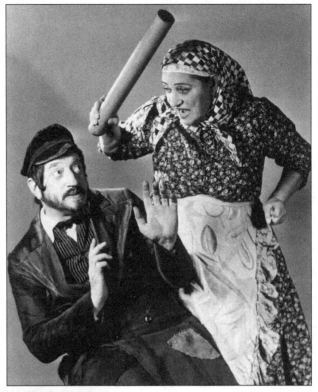

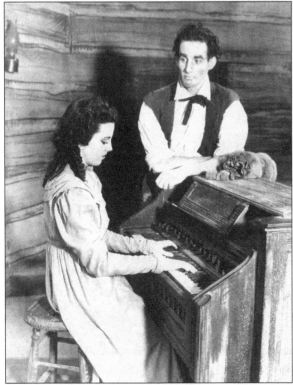

In the fall of 1938, the Walnut was taken over by the Federal Theatre Project. That December, it brought in a touring production of *Prologue to Glory* starring Stephen Courtleigh (right) and Ann Rutledge. The play, a reverent depiction of Abraham Lincoln's early years as a small-town lawyer in Illinois, was dismissed by critics.

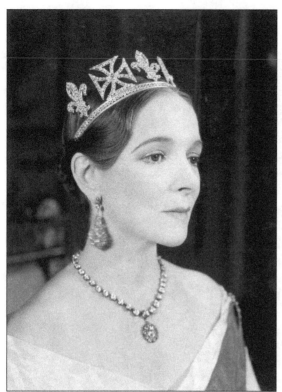

Helen Hayes was the toast of the 1938 Broadway season, appearing in Laurence Housman's play *Victoria Regina*. Hayes played Queen Victoria with Vincent Price in the role of Prince Albert.

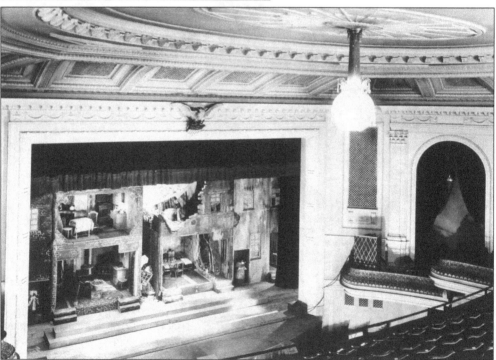

This image of the Walnut Street Theatre in 1938 shows the 1920 interior design by architect William H. Lee. The production onstage is unknown. (Courtesy of Athenaeum Philadelphia.)

Four

FROM 1941 TO 1968

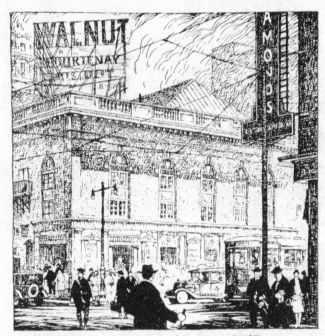

This image is of a souvenir postcard from the 1940s that was sold to promote the Walnut Street Theatre.

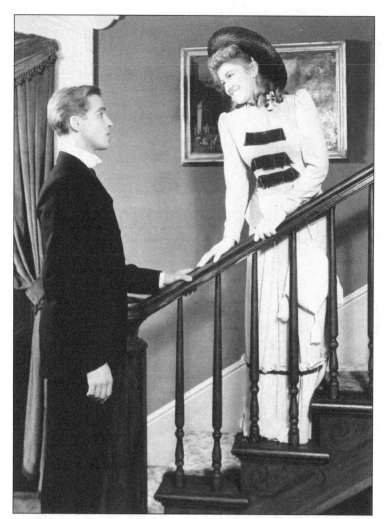

Following the Depression, it was a play about well-to-do family life on Park Avenue in the 1880s that had the most success on Broadway and on tour. *Life with Father*, starring Dorothy Gish (right) and her longtime lover Louis Calhern, played the Walnut for nearly three months in the spring of 1941. To avoid paying a large weekly percentage, producer Oscar Serlin bypassed the Shubert Organization in booking this production. His outspoken complaints about the Shuberts set in motion a federal investigation into them, which eventually resulted in antitrust charges against them. (Courtesy of the Theatre Collection, Free Library of Philadelphia.)

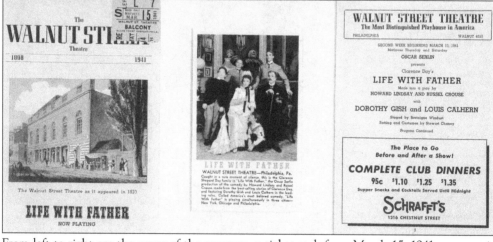

From left to right are the cover of the program, a ticket stub from March 15, 1941, a souvenir postcard, and the title page of the program from *Life with Father*.

At the height of his fame after completing the filming of *Citizen Kane*, Orson Welles (right) reaffirmed his place as the most talented director on the American stage with *Native Son*. Opening at the Walnut on February 23, 1942, Welles was innovative in his use of realism and expressionism to tell the story of an embittered black youth who accidentally kills the daughter of his white employer. The play did not include an intermission, and to prevent distracting noise from the rustling of pages, programs were not distributed until after the performance. The set and sound effects were instrumental in creating the oppressive world of the show's leading character, and critics and audiences raved over the production. (Courtesy of the Theatre Collection, Free Library of Philadelphia.)

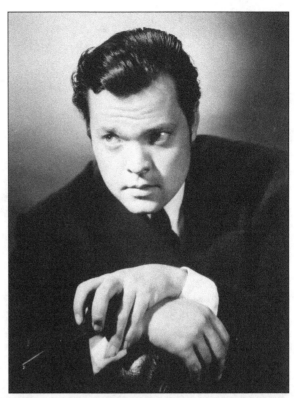

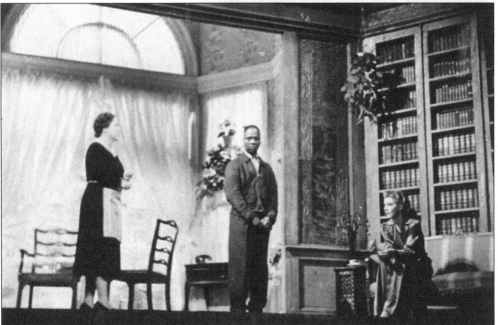

Canada Lee (center) starred in *Native Son*, one of the most powerful dramas of the era adapted for the stage. Lee was a former prizefighter, jockey, and nightclub owner who had remarkable range that allowed him to capture the extremes of his character. The other two actors are not identified.

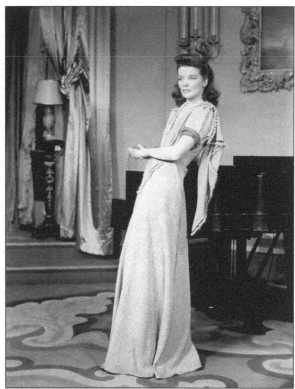

Katharine Hepburn's only appearance at the Walnut Street Theatre was in March 1942. She played a New England widow who operates a boardinghouse in Philip Barry's *Without Love*. Hepburn had previously worked with Barry on the successful stage and screen versions of *The Philadelphia Story*. In *Without Love*, Hepburn and her leading man, Elliot Nugent, were mismatched, and the production garnered mixed reviews. She was better suited to her partner in the film version of 1945, when she played opposite Spencer Tracey. (Courtesy of the Theatre Collection, Free Library of Philadelphia.)

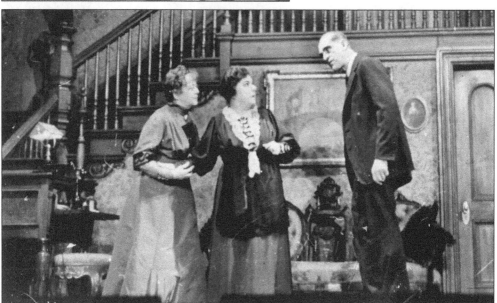

A touring company brought a three-week run of the hit *Arsenic and Old Lace* to the Walnut in April 1942. The play returned in January starring the original Broadway cast, including (from left to right) Josephine Hull, Jean Adair, and Boris Karloff (who had changed his name from William Pratt). The dark comedy about two sweet old ladies who lure lonely old men into their home and murder them was originally conceived as a serious thriller, but the producers turned it into a comedy, following their success with the hit comedy *Life with Father*.

Gregory Peck starred in the war-related play *The Morning Star* to open the 1942–1943 season. The show was not a success once it moved to New York, however, and Peck returned to the Walnut in November to try out *The Willow and I*. Peck went on to a successful film career, winning an Academy Award for his performance as Atticus Finch in the 1962 film *To Kill a Mockingbird*. (Courtesy of the Theatre Collection, Free Library of Philadelphia.)

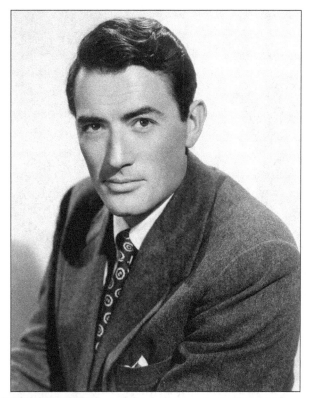

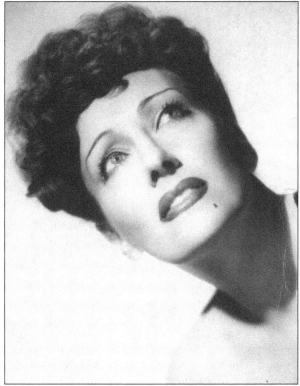

Gloria Swanson appeared at the Walnut during the 1942–1943 season in *Three Curtains*, a trio of one-act plays by George Bernard Shaw, J. M. Barrie, and Arthur Wing Pinero. The show was Broadway bound until there were problems with Swanson's costar during the Boston run, and the production was shut down. (Courtesy of the Theatre Collection, Free Library of Philadelphia.)

In the 1942–1943 season, John Barton starred in a tour of *Tobacco Road*. Based on the record-setting comedy novel by Erskine Caldwell, this play about Georgia sharecroppers was dramatized by Jack Kirkland in 1933 and was made into a film version directed by John Ford in 1941.

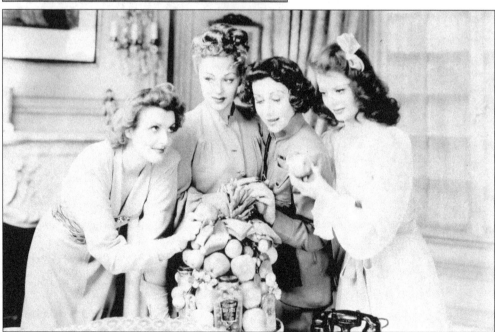

Comedies were especially popular in wartime America. *The Doughgirls*, starring (from left to right) Dorris Nolau, Virginia Field, Arlene Francis, and Arlene Whelan, played at the Walnut in the 1942–1943 season. Directed by George F. Kaufman, this comedy about gold diggers was set in wartime Washington, D.C. A film version was released in November 1944.

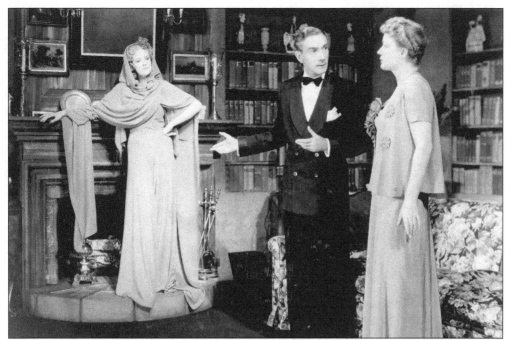

Opening on October 10, 1943, Noel Coward's *Blithe Spirit* was the highlight of the 1943 season. The production, starring (from left to right) Leonora Corbett, Clifton Webb, and Peggy Wood, came to the Walnut after its successful year-and-a-half Broadway run. In his autobiography, Coward claims he wrote the play in only five days while on holiday.

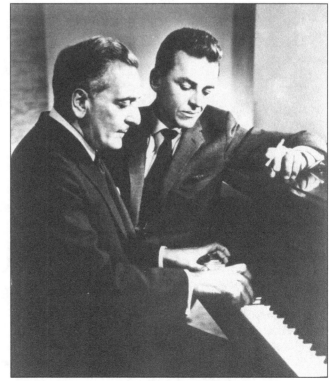

Lyricist Alan Jay Lerner (right) and composer Frederick Loewe came together for their first Broadway show with *What's Up?*, which tried out at the Walnut in the 1943–1944 season. It was a moderate success for the pair, who would go on to have major smash hits with shows like *Brigadoon*, *My Fair Lady*, and *Camelot*. (Courtesy of the Theatre Collection, Free Library of Philadelphia.)

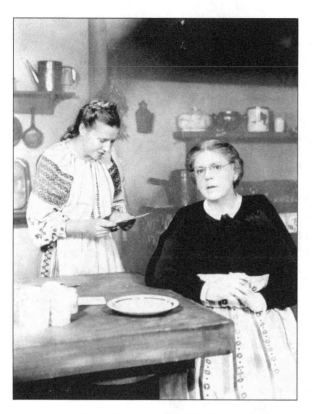

Ethel Barrymore (right) returned to the Walnut for the first time since 1900 to appear in the Theater Guild's presentation of *Embezzled Heaven* in October 1944. The other actress is unidentified. This stage adaptation of Franz Werfel's novel was Barrymore's last Broadway show.

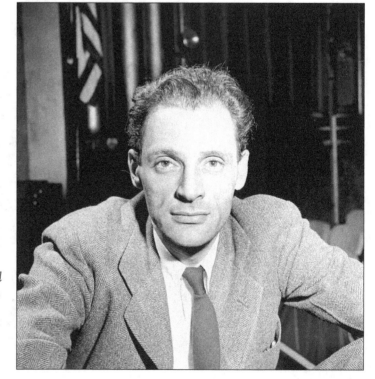

Playwright Arthur Miller debuted with the Broadway tryout of *The Man Who Had All the Luck* in November 1944. Although the play won the Theater Guild's National Award, it closed after only six performances on Broadway. Miller's career took off with his next Broadway production, *All My Sons*, and he went on to become regarded as one of America's greatest playwrights. (Courtesy of Eileen Darby Images, Inc.)

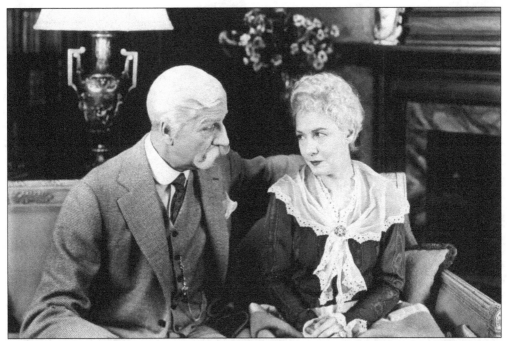

During the 1944–1945 season, Louis Calhern (left) and Dorothy Gish returned to the Walnut in *The Magnificent Yankee*. The play was a historical drama about Justice Oliver Wendall Holmes and his wife. Calhern reprised his role in the film version released in 1950.

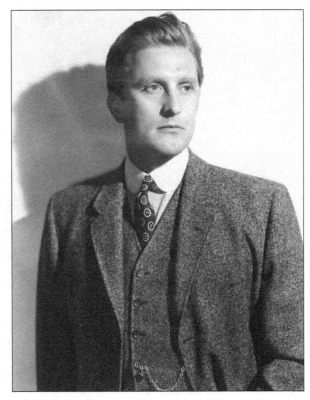

Kirk Douglas made his Walnut debut in the 1945–1946 season in a play called *Woman Bites Dog*, a riotous satire about an egotistic and fanatical newspaper owner who is determined to see bogeymen in every direction. Douglas went on to have a very successful screen career as both an actor and producer and to father another Hollywood star, Michael Douglas. (Courtesy of the Theatre Collection, Free Library of Philadelphia.)

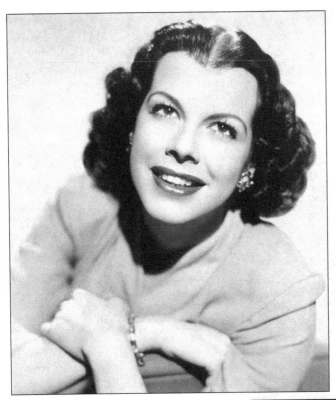

Jacqueline Susann (left), best known for penning best seller *The Valley of the Dolls*, cowrote *The Temporary Mrs. Smith* with Beatrice Cole. The play had its pre-Broadway tryout at the Walnut in the fall of 1946. (Courtesy of the Theatre Collection, Free Library of Philadelphia.)

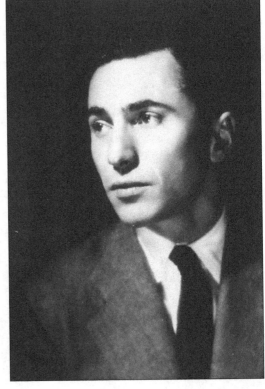

Heartsong, an early piece by Arthur Laurents (right), had its pre-Broadway tryout at the Walnut in March 1947. From the beginning, the production had problems, including the original leading lady quitting after only three days of rehearsal, the original leading man being replaced and then the replacement quitting, the original director being fired, and the script receiving extensive rewrites. When the show finally opened in Philadelphia, it was a flop and never made it to New York. Laurents's future career did not suffer, however, as he went on to write the libretto for such hit shows as *Gypsy* and *West Side Story*. (Courtesy of the Theatre Collection, Free Library of Philadelphia.)

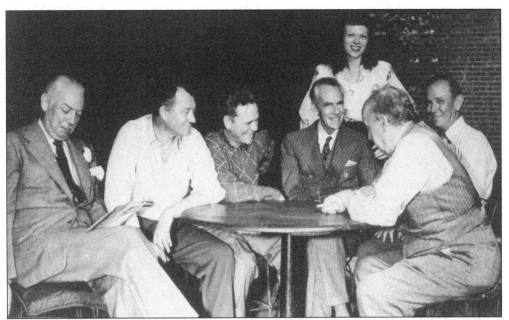

The Iceman Cometh by Eugene O'Neill arrived at the Walnut on April 7, 1947. It had been a dozen years since the last O'Neill piece played Philadelphia, and the production was highly anticipated. The play had opened on Broadway in 1946 without an out-of-town tryout and received mixed reviews. When the production was revived in 1956, however, it was fully realized as a masterpiece. Above is a reading of the play with the original cast and playwright Eugene O'Neill (center, in suit). (Courtesy of the Theatre Collection, Free Library of Philadelphia.)

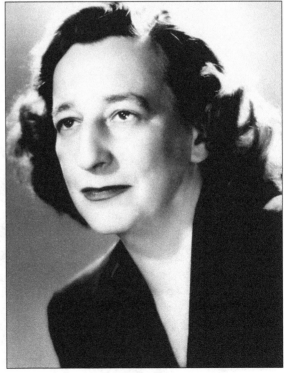

Lillian Hellman's *Another Part of the Forest* came to the Walnut in September 1947. The play was a prequel to her 1939 hit *The Little Foxes*. It had a successful Broadway run prior to its tour, and the show won three Tony Awards. A film version starring Frederic March was released in 1948. The playwright is pictured here. (Courtesy of the Theatre Collection, Free Library of Philadelphia.)

WALNUT STREET THEATRE

Week Beginning Monday, November 17, 1947
IRENE M. SELZNICK
presents

ELIA KAZAN'S PRODUCTION OF

A Streetcar Named Desire

by

TENNESSEE WILLIAMS

Directed by Mr. Kazan

with

JESSICA TANDY

Marlon	Kim	Karl
Brando	Hunter	Malden

Scenery and Lighting by
Jo Mielziner

Costumes Designed by
Lucinda Ballard

Assistant to the Producer
Irving Schneider

"And so it was I entered the broken world
To trace the visionary company of love, its voice
An instant in the wind (I know not whither hurled)
But not for long to hold each desperate choice."
—*The Broken Tower*, by Hart Crane

CAST
(In Order of Appearance)

NEGRO WOMAN	GEE GEE JAMES
EUNICE HUBBEL	PEG HILLIAS
STANLEY KOWALSKI	MARLON BRANDO
STELLA KOWALSKI	KIM HUNTER
STEVE HUBBEL	RUDY BOND
HAROLD MITCHEL (MITCH)	KARL MALDEN
MEXICAN WOMAN	EDNA THOMAS
TAMALE VENDOR	RICHARD CARLYLE
BLANCHE DU BOIS	JESSICA TANDY
PABLO GONZALES	NICK DENNIS
A YOUNG COLLECTOR	VITO CHRISTI
A STRANGE WOMAN	ANN DERE
A STRANGE MAN	RICHARD GARRICK

Habitues of the Quarter
A PLAY IN TWO PARTS
The action takes place in New Orleans in the present

On November 17, 1947, Tennessee Williams's *A Streetcar Named Desire* began its pre-Broadway tryout at the Walnut Street Theatre. Produced by Irene Mayer Selznick and directed by Elia Kazan, the production starred Marlon Brando and Jessica Tandy.

Marlon Brando was a relative newcomer to the professional theater scene when he starred as Stanley Kowalski in *A Streetcar Named Desire*. He had only one Broadway role to his credit and was virtually unknown outside New York. Brando was not even the original choice for the role. Producers wanted actor John Garfield, but Garfield felt it was a secondary role and passed. Marlon Brando was a critical success and went on to reprise his role in the 1951 film, playing opposite Vivien Leigh. (Courtesy of Eileen Darby Images, Inc.)

Jessica Tandy starred as Blanche Dubois in *A Streetcar Named Desire*, for which she won a Tony Award. This legendary star of stage and screen would go on to win additional Tony Awards for *The Gin Game*, *Foxfire*, and lifetime achievement. (Courtesy of Eileen Darby Images, Inc.)

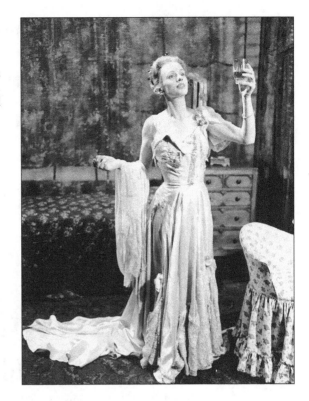

'Streetcar Named Desire Opens at the Walnut

By Edwin H. Schloss

In "A Streetcar Named Desire" Tennessee Williams is telling us the moving and absorbing story of a lost soul—a woman struggling in the ground swell of life desperately clinging to illusion and clutching frantically at any passing flotsam for survival.

The theme is essentially the same as that of Mr. Williams' prize-winning "The Glass Menagerie" of two seasons ago.

But the variations are vastly different.

The present case history is of grimmer stuff, and far more luridly lit.

REALISTIC WORK

As revealed at the Walnut Street Theater last night where it is stopping for a fortnight before bowing in on Broadway, the new play shows some symptoms of growing pains. But it has authentic magic of the theater, too.

Set in a sordid two-room apartment in the tenement section of New Orleans, it is written with realism that rises to poetry. Compassionate, and subtly wise in the ways of the crippled heart and mind, "Streetcar" travels from the gutter to the stars and tells us with tenderness and bitterness how close the two can be.

Blanche Du Bois, decayed relic of a wealthy Southern family, is a refugee from life and a school teacher's job in a small Mississippi town. She arrives, penniless but proudly bearing remnants of her old finery at her sister's home in the slums. Blanche comes literally (and symbolically) on a streetcar named "Desire"—it seems that they really have rolling stock with such fanciful titles in New Orleans.

HER MIND GOES

Her last pretense of gentility and her final citadel of feminine inviolability brutally torn apart, Blanche collapses over the border of fantasy into insanity. At the curtain she is being led to an asylum while Stanley and his friends continue their weekly poker game in the next room. And — a wonderful and pathetic touch, Blanche is happening to be in

"A STREETCAR NAMED DESIRE," a play in two parts by Tennessee Williams, staged by Elia Kazan, sets and lighting by Jo Mielziner, costumes designed by Lucinda Ballard and presented by Irene M. Selznick was given for the first time in this city at the Walnut Street Theatre last night. The cast:

Eunice Hubbel ———— Peg Hillias
Stanley Kowalski ——— Marlon Brando
Stella Kowalski ——— Kim Hunter
Steve Hubbel ———— Rudy Bond
Harold Mitchel (Mitch) — Karl Malden
Blanche Du Bois ——— Jessica Tandy
Pablo Gonzales ———— Nick Dennis

quet with the doctor who has come to take her away to the shadows.

Impersonating Blanche's pitiful gallantries and pathetic struggles Jessica Tandy last night gave an assisting and infinitely skillful, though at times uneven performance. Marlon Brando was superb as Stanley; Karl Malden not many steps behind as Mitch, Blanche's hulking, adolescent suitor. Kim Hunter was excellent as Stella. And the supporting parts were exceptionally well sustained.

DIRECTION GOOD

Elia Kazan's direction has sensitivity, thrust poetry, and an almost savage sincerity, "A Streetcar Named Desire" is not for those looking for light "amusement" in the playhouse. And Puritans and children had probably better stay back of the ropes. But in its ugliness is life; a deep wisdom and a moving tenderness. Blanche Du Bois is a symbol of the brutality of the world to its misfits; the horrible dependency of decency on money, the lack of understanding for the weak and tortured.

Partly for technical reasons (the lighting was not working too smoothly) and for reasons of emphasis and clarity of writing and performance, all its values did not cross the footlights last night. Put put it "streetcar" down as an absorbing play and an important event in this season. And perhaps by the time it reaches the Broadway tracks, as an event for next season, too.

Richardson Dilworth joins the distinguished roster of Inquirer columnist. Read his comments on Philadelphia's plans for improvements each Wednesday.

Philadelphia critics immediately recognized Tennessee Williams's *A Streetcar Named Desire* as a landmark production. This is the *Philadelphia Inquirer*'s opening night review of the world premiere at the Walnut.

Mister Roberts was the Tony Award–winning best play for 1948. The wartime comedy opened at the Walnut in January 1948 for its pre-Broadway tryout.

From left to right, Jocelyn Brando (Marlon Brando's sister) and Murray Hamilton appeared in *Mister Roberts*.

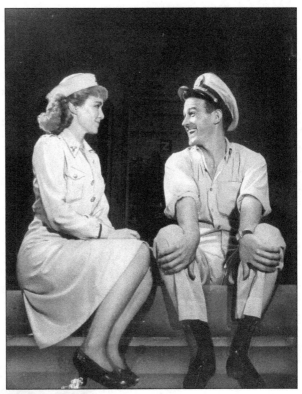

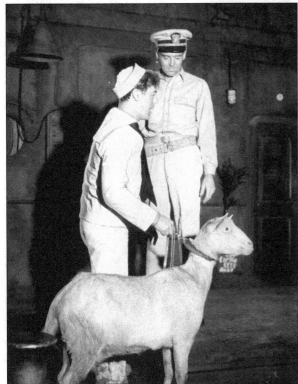

Mister Roberts starred Henry Fonda (right) as a soft-spoken navy lieutenant. Fonda had recently been discharged from the navy and used his own uniform in the play. He is shown here with costar Casey Watlers and an unidentified goat.

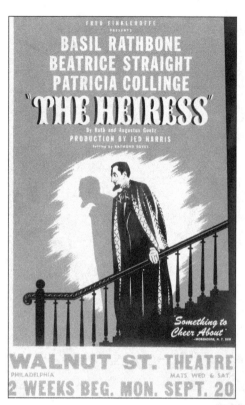

The Heiress was the first show of the 1948 fall season, opening in September. The play, an adaptation of Henry James's novel *Washington Square* by Augustus and Ruth Goetz, starred Basil Rathbone. Rathbone won a Tony Award for his performance. A film version starring Olivia de Havilland and Montgomery Clift was released in 1949.

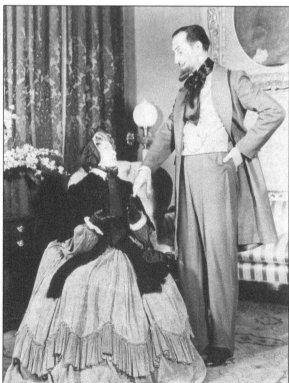

Pictured here are Betty Linley (left) and Basil Rathbone in *The Heiress* in 1948.

Life with Mother played the Walnut in the fall of 1948. Written by Howard Lindsay and Russel Crouse, the play was a sequel to their highly successful *Life with Father*, which had just closed after an eight-year Broadway run. The production featured (from left, clockwise) Robert Antoine, Dorothy Stickney, Howard Lindsay, David Frank, and Robert Wade.

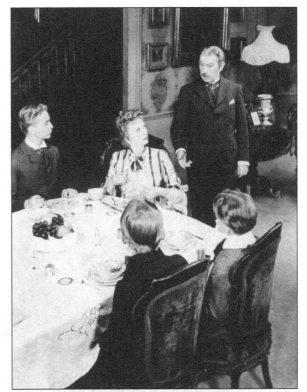

George Bernard Shaw's *Man and Superman* played for a brief run during the 1947–1948 season. The show was directed by and starred Maurice Evans (left), shown with costar Jack Manning. British actor Evans was known for both his Shakespeare and Shaw pieces but might be most recognized for creating the role of Dr. Zaius in the 1968 film *Planet of the Apes*.

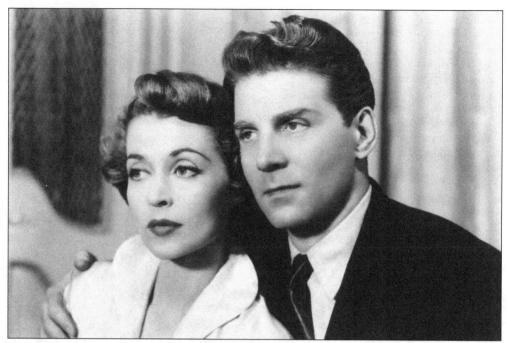

French film star Jean Pierre Aumont (right) wrote and starred in *Figure of a Girl* opposite Lilli Palmer. The comedy was then adapted by Philip Barry, and the name was changed to *My Name Is Aquilon* for its transition to Broadway, where it only played for one month.

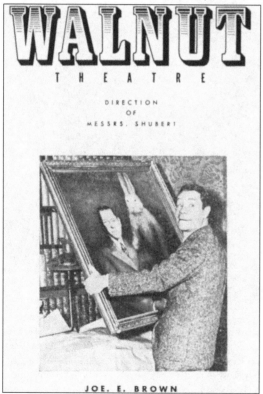

The highlight of the 1947–1948 season was a touring production of *Harvey* featuring Joe E. Brown as Elwood F. Dowd. The production was directed by Antoinette Perry, for whom the Tony Awards are named. (Courtesy of the Theatre Collection, Free Library of Philadelphia.)

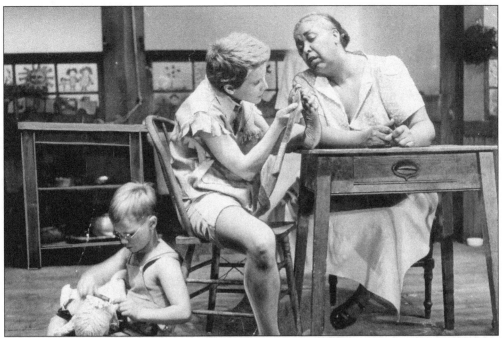

Carson McCullers's *The Member of the Wedding* played its pre-Broadway tryout at the Walnut Street Theatre in December 1949 and was the hit of the season. The production starred, from left to right, Brandon De Wilde, Julie Harris, and Ethel Waters, who were all critically acclaimed for their performances. All three reprised their stage roles for the 1952 film version.

This is the title page from the program for *The Member of the Wedding*. (Courtesy of the Theatre Collection, Free Library of Philadelphia.)

WALNUT STREET THEATRE
9th and WALNUT STREETS

Week Beginning Monday, December 26, 1949

Robert Whitehead, Oliver Rea and Stanley Martineau
present

ETHEL WATERS

in

"THE MEMBER OF THE WEDDING"

by CARSON McCULLERS

with JULIE HARRIS

Directed by HAROLD CLURMAN
Settings, Costumes and Lighting by Lester Polakov
C A S T
(In the order of speaking)

JARVIS	JAMES HOLDEN
FRANKIE ADDAMS	JULIE HARRIS
JANICE	JANET De GORE
BERENICE SADIE BROWN	ETHEL WATERS
ROYAL ADDAMS	WILLIAM HANSEN
JOHN HENRY WEST	BRANDON de WILDE
MRS. WEST	MARGARET BARKER
HELEN FLETCHER	MITZIE BLAKE
DORIS	JOAN SHEPARD
MURIEL	PHYLLIS ANN LOVE
SIS LAURA	PHYLLIS WALKER
T. T. WILLIAMS	HARRY BOLDEN
HONEY BROWN	HENRY SCOTT
SOLDIER	JOHN FIEDLER
PEROXIDE BLOND	EUGENIA WILSON
CAL	WILLIAM LANTEAU
BARMAN	HOWARD FISCHER
MONKEY MAN	ALFRED MATRIZO
BARNEY McKEAN	BILLY JAMES

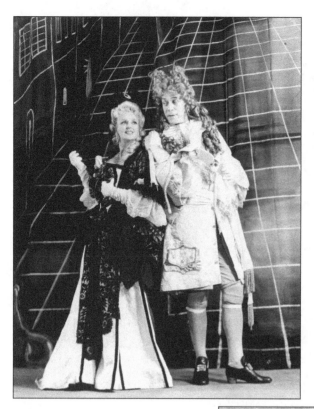

In the fall of 1951, the Theatre Guild opened the Walnut's season with *The Relapse, or Virtue in Danger*. This 17th-century comedy of manners was directed by and starred Cyril Ritchard. He stole the show as Lord Foppington, a role that resembled his most famous role as Captain Hook in the 1954 production of *Peter Pan*. Ritchard is shown here with costar Madge Elliot.

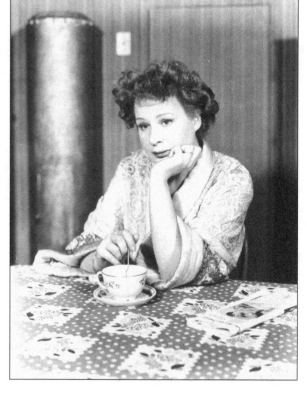

Shirley Booth starred in the tour of William Inge's *Come Back Little Sheba* in January 1951. Booth and her costar Sidney Blackmer had both received 1950 Tony Awards for their performances as an alcoholic chiropractor and his slovenly wife. This play established William Inge as an important dramatist, and future projects included *Bus Stop*, *The Dark at the Top of the Stairs*, Academy Award–winning *Splendor in the Grass*, and Pulitzer Prize–winning *Picnic*.

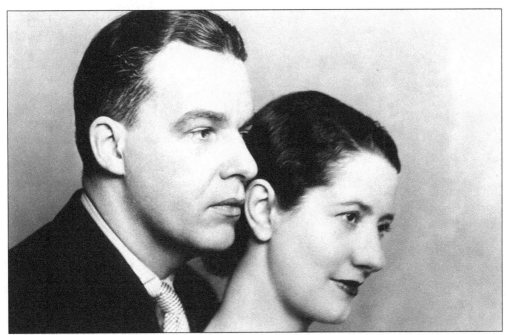

Alfred Lunt and Lynn Fontanne were Broadway's preeminent acting couple. Together they performed in over 24 plays, have a Broadway theater named after them, and were recently commemorated on a postage stamp. The pair made their only Walnut appearance in February 1951 with *I Know My Love*. The romantic comedy centered around a couple's life together over 50 years. The acting team was celebrating 25 years together and saw the play as a parable of their marriage. (Courtesy of the Theatre Collection, Free Library of Philadelphia.)

At age 22, a virtual unknown beauty named Audrey Hepburn (left) made her Walnut debut in the world premiere of *Gigi*, starring opposite Cathleen Nesbitt. The play was adapted from the Toni Collette novel of the same name, and Collette handpicked Hepburn to star in the production after seeing her on a film set. Hepburn had started off studying ballet, but she realized she was not an advanced enough dancer to pursue that as a career and crossed over to stage performance. Her success on Broadway was short-lived, as she quickly went on to a major film career.

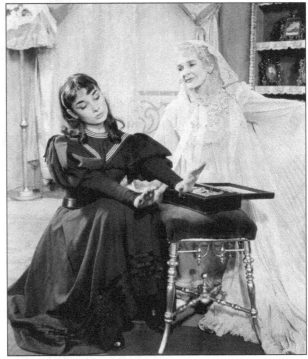

Jose Ferrer (left) directed and starred in the pre-Broadway tryout of *The Shrike* in January 1952, for which he went on to win Tony Awards as both best director and best actor. He came back to direct two more productions at the Walnut: *Stalag 17* in late 1952, which went on to become a movie of the same name and the inspiration for television's series *Hogan's Heroes*, and *The Andersonville Trial* in 1959, starring George C. Scott. (Courtesy of the Theatre Collection, Free Library of Philadelphia.)

The opening show of the fall 1952 season was Arthur Laurents's *The Time of the Cuckoo* starring Shirley Booth (left) opposite Dino DiLuca. The show was a success, and Booth received her third Tony Award for best actress. In her successful theater, film, and television career, Booth was also an Academy Award, Golden Globe Award, and Emmy Award winner, perhaps best known for her role late in life on the television sitcom *Hazel*. (Courtesy of the Theatre Collection, Free Library of Philadelphia.)

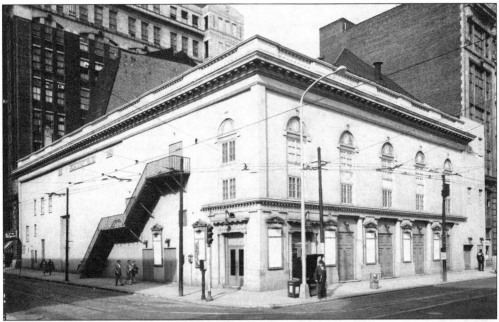

Seen here is an exterior view of the Walnut Street Theatre in 1952 as it was redesigned by William H. Lee in 1920. One will note that there was no major signage or marquee on the Walnut Street Theatre, with the name of the theater being displayed on the Ninth Street side only and discreet poster boards in between the doors. The only concession the architect made to the "Great White Way" was the row of electric lightbulbs mounted above the doors. (Courtesy of the Library of Congress, Prints and Photographs Division.)

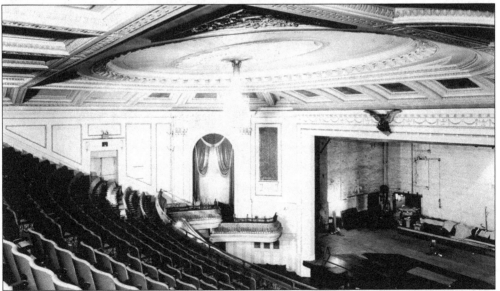

This interior photograph taken in 1952 shows the 1920 interior designed by William H. Lee. The only architectural remnants from the 19th century were the wooden eagle over the proscenium arch and the wooden stage machinery above the stage. From 1920 until 1969, there were no renovations made to the building. (Courtesy of the Theatre Collection, Free Library of Philadelphia.)

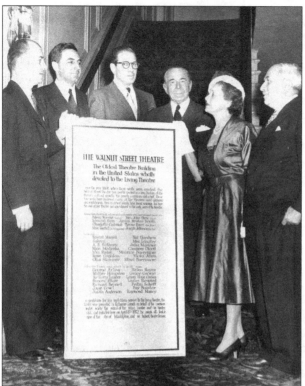

On April 15, 1952, Katherine Cornell (second from the right) presented the Walnut Street Theatre with a plaque on behalf of the American Theatre Society, the Council of the Living Theatre, and the Theatre Guild to celebrate "the Oldest Theatre Building in the United States wholly devoted to the Living Theatre." Also pictured are (from left to right) actor Brian Ahern, an unidentified Philadelphia official, Warren Caro (secretary, the Council of the Living Theatre), Lee Shubert (theater owner), and Lawrence Langner (the Theatre Guild). (Courtesy of the Shubert Archive.)

In March 1954, following a successful run on Broadway, *Dial M for Murder* came to the Walnut. The production starred Maurice Evans (left), shown above with author Frederick Knott. A film version directed by Alfred Hitchcock was released the same year. (Courtesy of the Theatre Collection, Free Library of Philadelphia.)

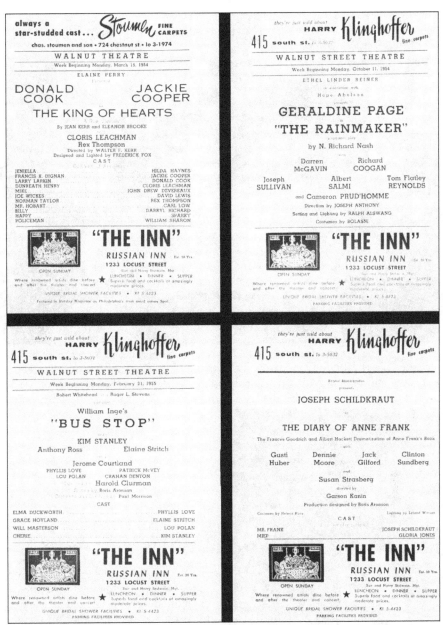

The years 1954 and 1955 saw four important productions that all played pre-Broadway tryouts at the Walnut. These images are title pages from the programs. Cloris Leachman starred in *The King of Hearts* (top left) in 1954. The following year, she began her long and ongoing film and television career. *The Rainmaker* (top right), by Philadelphia-born N. Richard Nash, went on to become an American classic. The year 1955 saw the production of William Inge's *Bus Stop* (bottom left), which is best known today for the film version starring Marilyn Monroe. *The Diary of Anne Frank* (bottom right) had its world premiere at the Walnut on September 15, 1955. The production received rave reviews and went on to a two-year Broadway run. The play swept the New York awards circuit, winning the Tony Award for best play, the New York Drama Critics Circle Award, and the Pulitzer Prize for drama. (Courtesy of the Theatre Collection, Free Library of Philadelphia.)

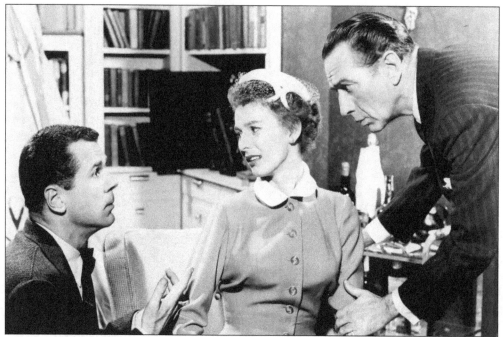

The King of Hearts, starring (from left to right) Jackie Cooper, Cloris Leachman, and Donald Cook, finished out the 1953–1954 season. This farce by Jean Kerr and Eleanor Brooke went on to have a successful Broadway run, playing almost 300 performances. (Courtesy of the Theatre Collection, Free Library of Philadelphia.)

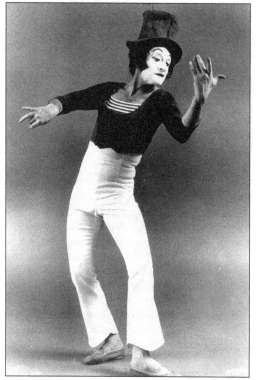

During Thanksgiving week 1956, Marcel Marceau performed a week of pantomime at the Walnut. Marceau was visiting on his first tour of the United States, and critics were enchanted by his performance. He went on to become world famous for his silent art, appearing in television and film and even writing several children's books. Before his death in September 2007, Marceau was honored by the French government, awarded several honorary doctorates from various American universities, served as a goodwill ambassador for the United Nations, and had a holiday proclaimed in his honor when in 1999 New York City declared March 18 to be Marcel Marceau Day. (Courtesy of Ira Kamens.)

Many productions in the 1956–1957 season were opportunities for Hollywood stars to take a break from their film and television careers and return to the stage. Oscar-winning actress Shelley Winters starred in N. Richard Nash's play *The Girls of Summer*. Winters is best known for her film roles in *A Place in the Sun*, *The Diary of Anne Frank*, and *The Poseidon Adventure*. (Courtesy of the Theatre Collection, Free Library of Philadelphia.)

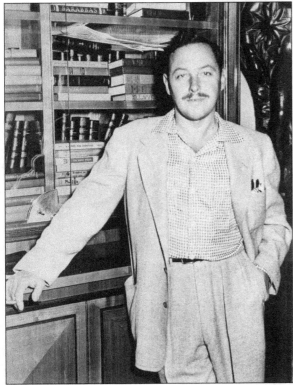

In March 1957, Tennessee Williams's *Orpheus Descending* played two weeks at the Walnut prior to moving to Broadway. A modern retelling of the ancient Greek legend of Orpheus, the play was a reworking of an earlier Williams piece called *Battle of Angels*, which closed in tryouts in 1940. The playwright is pictured here. (Courtesy of the Theatre Collection, Free Library of Philadelphia.)

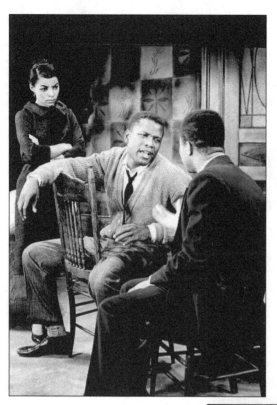

A *Raisin in the Sun* opened at the Walnut on January 26, 1959. Starring (from left to right) Ruby Dee, Sidney Poitier, and Lonne Elder III, the production was a success on Broadway and was nominated for four Tony Awards, including best actor and best play. Notably, it was the first play written by a black woman (Lorraine Hansberry) to be produced on Broadway and was the first Broadway play directed by a black man (Lloyd Richards). (Courtesy of the Theatre Collection, Free Library of Philadelphia.)

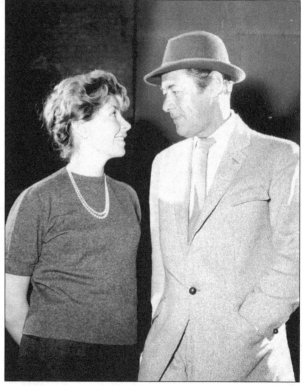

In November 1959, Rex Harrison (right) appeared in *The Fighting Cock* opposite Odile Versois. The satire featured Harrison as a retired general based on French general Charles de Gaulle, and his makeup for opening night included a putty nose, bushy eyebrows, and a wig. The audience was disappointed that they could not even recognize Harrison, famed star of *My Fair Lady*, and the makeup was cut from future performances. (Courtesy of the Theatre Collection, Free Library of Philadelphia.)

Hollywood star Lauren Bacall appeared in *Goodbye, Charlie* during the 1959–1960 season. Bacall played a man who is reincarnated as a woman, to be taught a lesson by God on how it feels to be a woman mistreated by men like him. A film version starring Debbie Reynolds was released in 1964. (Courtesy of the Theatre Collection, Free Library of Philadelphia.)

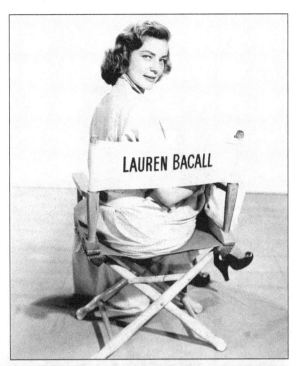

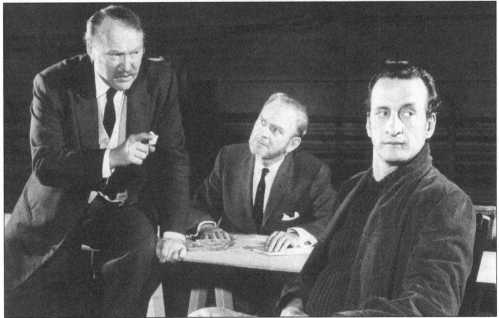

From left to right, Albert Dekker, Russell Hardie, and George C. Scott starred in *The Andersonville Trial* in the 1959–1960 season. The play is based on the actual 1865 trial of Henry Wirz, commander of the infamous Confederate Andersonville prison, where thousands of Union prisoners died of exposure, malnutrition, and disease. Scott went on to earn a Tony nomination for his performance when the show moved to Broadway. He later directed a television adaptation for CBS's 1970–1971 season that garnered two Emmy Awards. (Courtesy of the Theatre Collection, Free Library of Philadelphia.)

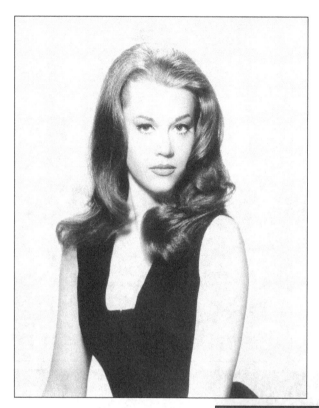

Jane Fonda premiered at the Walnut on February 9, 1960, in her first important stage role, playing a rape victim in *There Was a Little Girl*. Daughter of Walnut veteran and Hollywood star Henry Fonda, Jane went on to become a two-time Academy Award winner, political activist, and fitness guru. (Courtesy of the Theatre Collection, Free Library of Philadelphia.)

Jack Lemmon opened the 1960–1961 season playing the role of David Poole in *Face of a Hero*. Still early in his stage career, Lemmon was not well received by Philadelphia critics. However, he went on to become one of the most well-known actors and comedians in America, starring in such films as *Some Like It Hot*, *The Apartment*, and *The Odd Couple*. (Courtesy of the Theatre Collection, Free Library of Philadelphia.)

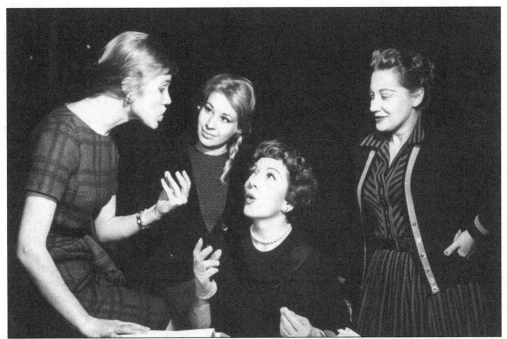

Claudette Colbert, Hollywood's leading lady of the 1930s and 1940s, had come from a successful Broadway career in the 1920s before crossing over to film. She then made a return to theater beginning in the late 1950s. Seated center with (from left to right) Laryssa Lauret, Ludmilla Tehor, and Lynne Charnay, Colbert appeared in the 1961 pre-Broadway tryout of *Julia, Jake and Uncle Joe* at the Walnut. The comedy by Oriana Atkinson, wife of *New York Times* drama critic Brooks Atkinson, was not a success once it reached New York. It closed after only one performance on Broadway. (Courtesy of the Theatre Collection, Free Library of Philadelphia.)

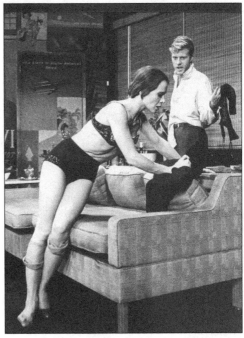

Robert Redford came to Philadelphia for the first time when he starred in *Sunday in New York* at the Walnut in 1961. Shown in a scene from the play with Pat Stanley, Redford (right) played the music critic for the *Philadelphia Inquirer* who gets romantically involved with a music critic from Albany during a visit to New York. Although not acclaimed locally, the play went on to moderate Broadway success and was made into a film version the following year. (Courtesy of the Theatre Collection, Free Library of Philadelphia.)

The final show of the 1960–1961 season was Neil Simon's *Come Blow Your Horn*. This was Simon's first full-length play, and it was a huge hit with Philadelphia audiences. The critics in New York were less responsive, but the play went on to run for nearly two years on Broadway and launched Simon's playwriting career. Throughout his life, he has garnered 17 Tony nominations and won three, he won a Pulitzer Prize for *Lost in Yonkers*, he has written the screenplay for over 20 films for which he has received four best screenplay Oscar nominations, he has received two honorary doctorates, he has a Broadway theater named in his honor, and he is an honorary member of the Walnut Street Theatre's board of trustees. (Courtesy of the Theatre Collection, Free Library of Philadelphia.)

A *Shot in the Dark* opened in October 1961. The show featured a notable cast, including Walter Matthau, Julie Harris, and William Shatner. Matthau was a late addition to the cast, only brought in to the production after actor Donald Cook died during earlier tryouts. Matthau went on to win a Tony Award for best supporting actor for his acclaimed performance. William Shatner went on to fame in *Star Trek* and *Boston Legal*.

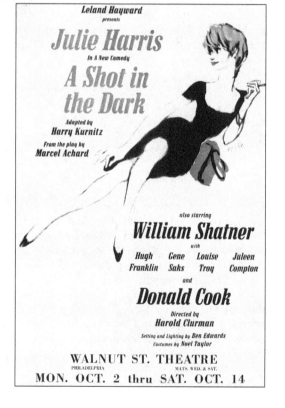

In March 1962, Eva Le Gallienne brought her successful tour of two dramas about Queen Elizabeth I to the Walnut. She played the title roles in *Mary Stuart* and *Elizabeth the Queen* (pictured here with Alfred Lunt) and was praised for her portrayal of both. Despite her somewhat scrutinized personal life as a homosexual, Le Gallienne is noted as a successful Broadway actress and producer of repertory theater, an Emmy Award winner, an Oscar nominee, and the recipient of a special Tony Award in 1964 and the National Medal of Arts in 1986. (Courtesy of the Theatre Collection, Free Library of Philadelphia.)

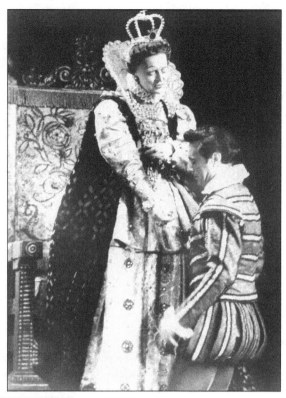

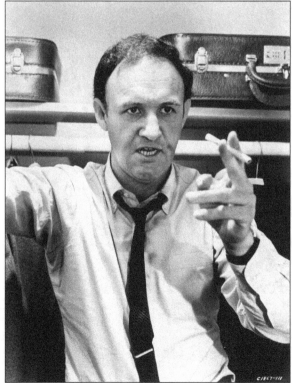

A Rainy Day in Newark played at the Walnut in the 1963–1964 season before it moved to Broadway. The show was a flop and only ran seven total performances in New York. However, a supporting role in the play opened the door for Gene Hackman, who went on to become a two-time Academy Award winner. (Courtesy of the Theatre Collection, Free Library of Philadelphia.)

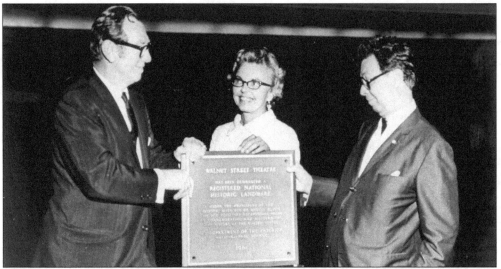

In 1964, the U.S. Department of the Interior designated the Walnut Street Theatre as a national landmark. It presented the Walnut with a plaque stating that "this site possesses exceptional value in commemorating and illustrating the history of the United States." Shown above standing with the plaque are, from left to right, Lawrence Shubert Lawrence Jr., head of the Shubert Organization at the time; Dorothy Haas, a civic leader and future vice president of the Walnut Street Theatre Corporation; and Phillip Klein, civic leader and future president of the Walnut Street Theatre Corporation. Both Haas and Klein were major participants in the 1969 restoration project.

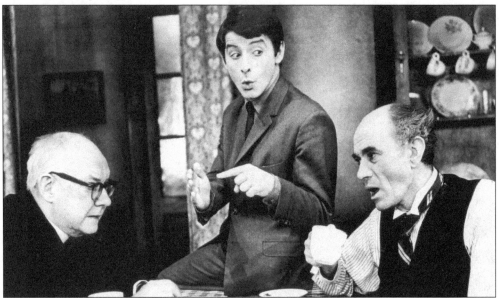

The 1965–1966 season featured the Irish comedy *Philadelphia, Here I Come!* The cast, which included, from left to right, Donald Mayre, Donal Donnelly, and Eamon Kelly, was brought from Ireland, and the show made its American premiere at the Walnut before it moved to Broadway. It had a successful run in New York and was nominated for six Tony Awards. The show was revived on Broadway in 1994 and at the Walnut in 1996. (Courtesy of the Theatre Collection, Free Library of Philadelphia.)

The 1966–1967 season opened with Woody Allen's first stage success, *Don't Drink the Water*. Lou Jacobi and Vivian Vance (best known as Ethel from *I Love Lucy*, shown from left with the playwright) starred in this comedy set in an American embassy somewhere behind the iron curtain. The show suffered from multiple cast changes and a lack of direction during tryouts, but the audiences responded well to the humor, and it ran for almost 600 performances on Broadway. (Courtesy of the Theatre Collection, Free Library of Philadelphia.)

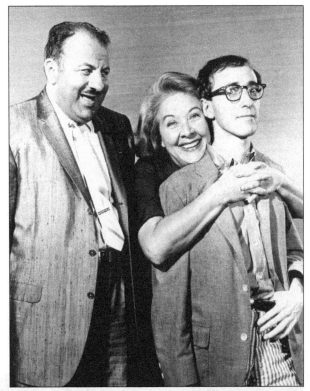

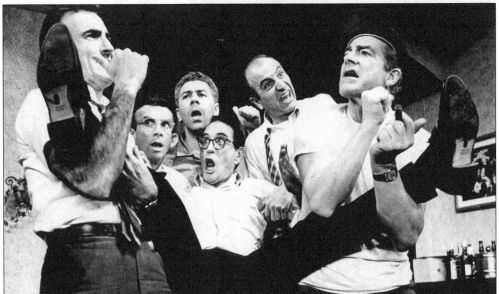

Another Neil Simon hit played at the Walnut when a tour of *The Odd Couple* came through to open the 1967–1968 season. The cast, from left to right, included Page Johnson, Don McArt, Bob Busso, Robert Q. Lewis, Bill Browder, and Dave Andrews. The play, which won several Tony Awards its first time on Broadway, has experienced two Broadway revivals and was the basis for a successful television series and film of the same name. (Courtesy of the Theatre Collection, Free Library of Philadelphia.)

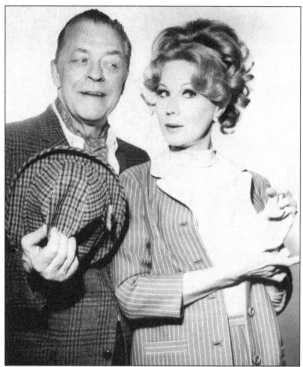

A touring production of another popular Neil Simon play came late in the 1967–1968 season. Lyle Talbot (left) and Virginia Mayo starred in *Barefoot in the Park*, which to date is Simon's longest-running Broadway show, having played 1,530 performances. (Courtesy of the Theatre Collection, Free Library of Philadelphia.)

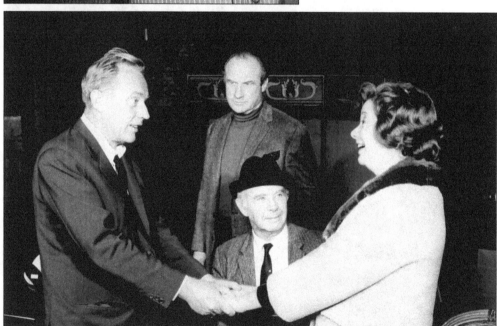

Arthur Miller brought a new production to the Walnut for the 1968 season. Clockwise from the center, Harold Gary, Pat Hingle, Arthur Kennedy, and Kate Reid starred in *The Price*, a drama about two estranged brothers who come together over the sale of their father's estate. The original director had conflicts with the cast, so Miller had to take over the duties of director during tryouts. The production went on to become one of Miller's longest-running plays. (Courtesy of the Theatre Collection, Free Library of Philadelphia.)

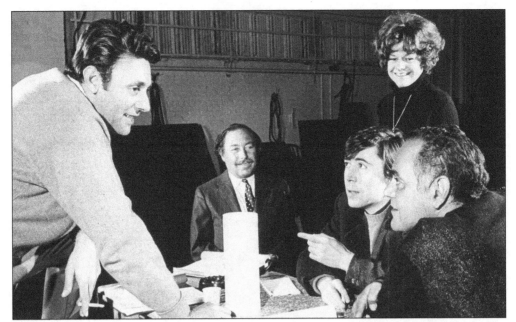

In March 1968, Tennessee Williams's *The Seven Descents of Myrtle* came to the Walnut. The playwright, shown center with the original cast and director at a read through of the play, was drinking heavily and taking amphetamines, which affected both his writing and his attendance at rehearsals. Many considered the play an artistic failure, and it closed on Broadway after only 29 performances. (Courtesy of the Theatre Collection, Free Library of Philadelphia.)

A musical adaptation of William Shakespeare's *Twelfth Night*, entitled *Your Own Thing*, opened at the Walnut on November 6, 1968. The New York production was the first off-Broadway show to have received the New York Critics Circle Award for best musical. The musical was a success in Philadelphia as well and played at the Walnut for 20 weeks. The cast of the rock-style musical is pictured here. (Courtesy of the Theatre Collection, Free Library of Philadelphia.)

This image shows the 19th-century eagle that hung above the proscenium arch until the 1969 renovation. Although there is no documentary evidence concerning the eagle, the only clue to the date is the number of stars on the shield. There are 35 stars, which would place the carving between June 1863 when West Virginia became the 35th state and October 1864 when Nevada entered the union. Today the eagle hangs in the mezzanine lobby.

This photograph shows the chandelier that hung in the center of the ceiling from 1920 until 1969. The chandelier was originally made for, and originally hung in, Philadelphia's Bingham Hotel.

Five

FROM 1969 TO 1982

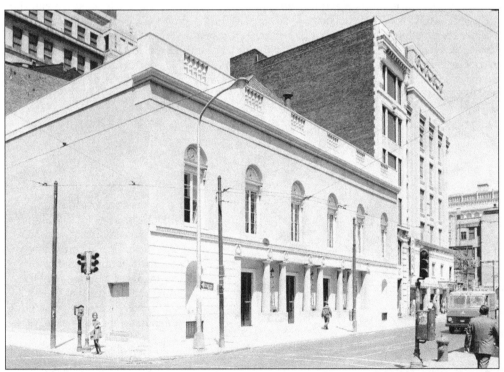

In 1969, the Haas Community Fund purchased the Walnut Street Theatre and established it as a not-for-profit organization. The theater was in need of extensive renovations. After a broad investigation of the building was completed, it was decided that the only possible approach was to renovate the interior and restore the exterior to its 1828 appearance, originally designed by John Haviland. This photograph shows the theater after the exterior restoration was completed.

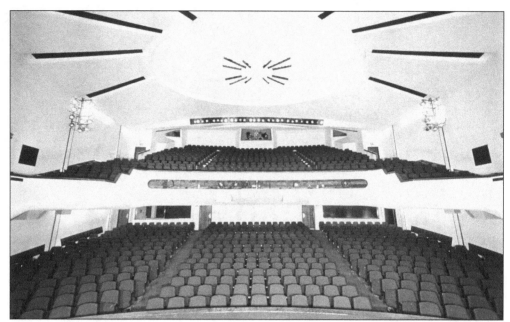

With limited information on the original 19th-century interior, the decision was made to modernize the theater as opposed to renovating the 1920 interior. The lobbies and auditorium were completely modernized. The historic stage and its rigging were left virtually intact. The theater reopened as a performing arts center and hosted a variety of dance, film, music, and theatrical events. Local organizations that appeared in the 1970s included the Academy of Vocal Arts, Concerto Soloists of Philadelphia, Marlboro Music, Philadanco, Pennsylvania Ballet, The Pennsylvania Opera Theatre, and Theatre Arts for Youth.

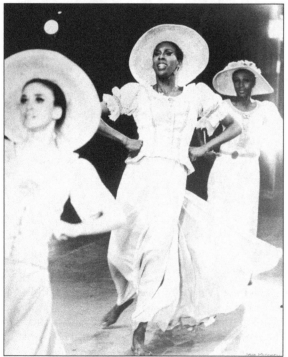

Dance events were featured prominently as part of the Walnut's seasons as a community arts center. The American Dance Festival brought six major modern dance companies to the Walnut in 1971, including the Alvin Ailey American Dance Theater Company performing Ailey's choreographical masterpiece *Revelations*. Shown in this photograph, *Revelations* is based on Ailey's experience growing up as an African American in the South and is today among the best known and most frequently seen of modern dance performances. (Courtesy of Hulton Archive/Staff/Getty Images.)

In 1972, Chita Rivera (left) appeared in a Philadelphia Drama Guild production of Garson Kanin's *Born Yesterday* with John Randolph. Rivera played Billie Dawn, the dumb-like-a-fox ex-chorine originally played on Broadway by Judy Holliday. Rivera is best known as the original Anita in the Broadway production of *West Side Story*, which paved her way to Broadway and Tony Award–winning stardom. She also originated roles in *Bye Bye Birdie, Chicago, Kiss of the Spider Woman*, and many other legendary productions. (Courtesy of Ira Kamens.)

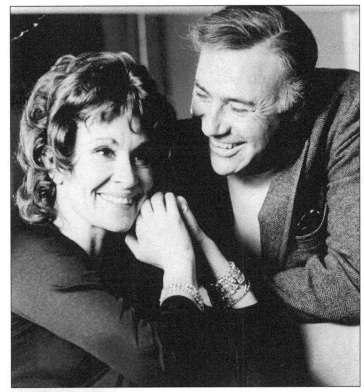

When the Walnut reopened as a presenting house in 1971, the Philadelphia Drama Guild was invited to become the resident theater company. The group was founded in 1956 and had developed a reputation for producing plays for school groups. When it became the resident theater company of the Walnut, the drama guild transformed itself from an amateur community group to a professional acting company. The image here is the 1972–1973 season poster for the drama guild, which included *Tartuffe, Waltz of the Toreadors, Ceremonies in Dark Old Men*, and *Juno and the Paycock*.

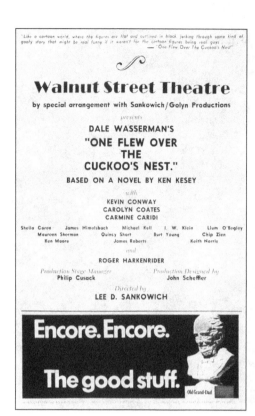

This image shows the title page from the program for the 1972 fall season opener, a touring production of *One Flew over the Cuckoo's Nest*.

This image is the cover of the playbill for Bob Randall's comedy *6 Rms Riv Vu*. The production, starring Jerry Orbach (left) and Jane Alexander, played a two-week pre-Broadway tryout beginning on September 25, 1972. Orbach was a major Broadway and off-Broadway star, having originated roles in *The Fantasticks*; *Carnival*; *Promises, Promises*; and later in *Chicago* and *42nd Street*. He went on to a notable film and television career, playing many varied roles, including Baby's father in *Dirty Dancing*, the voice of Lumiere in Disney's animated musical *Beauty and the Beast*, and the wisecracking detective Lennie Brisco on *Law and Order*.

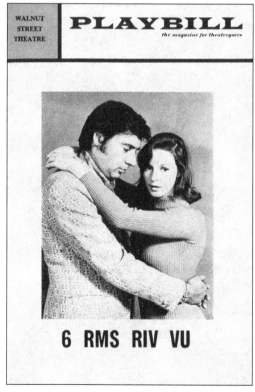

In October 1972, a national tour of the controversial nude revue *Oh! Calcutta!* came to the Walnut for a three-week run. Made up of sketches based on various sex-related topics, the show's title is taken from a painting by Clovis Trouille, itself a pun on "O quel cul t'as!," French for "What an ass you have!"

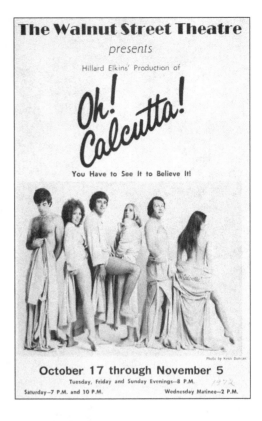

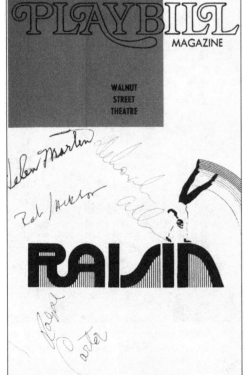

This playbill cover is signed by actor/choreographer Debbie Allen, who appeared as Beneatha Younger in *Raisin* at the Walnut in fall 1973. This musical version of *A Raisin in the Sun* went on to Broadway where it won the 1974 Tony Award for best musical. A few years later, Allen starred in Broadway revivals of *West Side Story* and *Sweet Charity* and played Lydia Grant in the hit television series *Fame*.

Beginning on June 12, 1975, Vivian Reed starred in the pre-Broadway tryout of *Bubbling Brown Sugar* at the Walnut. The musical revue celebrated the Harlem Renaissance, featuring over 30 musical numbers by celebrated black artists such as Earl Hines, Duke Ellington, Count Basie, and Billie Holiday. When the production moved to Broadway, it was nominated for three Tony Awards, including best musical, best choreography, and best actress (Vivian Reed). The show was revived at the Walnut by Philadelphia producer Moe Septee in the summer of 1985.

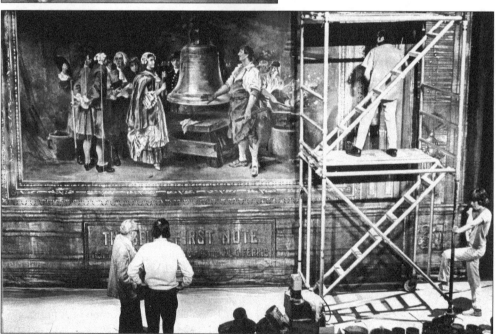

During the 1975–1976 season, the Walnut's historic fire curtain underwent a $10,000 restoration. The curtain features a hand-painted reproduction of a painting of the Liberty Bell's casting called *The Liberty Bell's First Note, 1753*, originally painted by Jean Leon Gerome Ferris. This historic fire curtain still hangs above the stage today. (Courtesy of the Athenaeum of Philadelphia.)

The Walnut celebrated the nation's bicentennial and its own 168th birthday by hosting the Emmett Kelly Jr. Circus on February 1, 1976. Kelly followed in his father's footsteps in the entertainment industry. Kelly Sr. was recognized as one of the most famous tramp clowns of the circus. Kelly Jr. toured with several circuses, entertained at over 2,800 hospitals, and was featured in print and commercial advertisements.

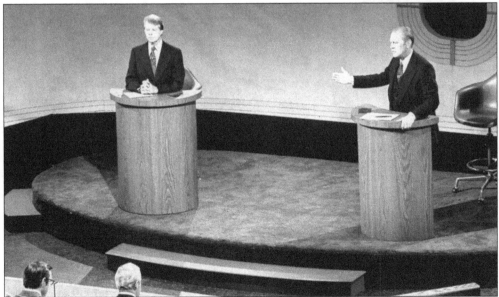

On September 23, 1976, Pres. Gerald R. Ford (right) and his Democratic challenger, Jimmy Carter, came to the Walnut Street Theatre for the first of their three debates that fall. That encounter marked the first time in United States history that a president had agreed to debate and only the second time (after 1960) that any televised debates had been held. During the debate, the sound system failed, leaving Ford and Carter standing at their lecterns in uncomfortable silence for nearly half an hour. (Courtesy of the Library of Congress, Prints and Photographs Division.)

During summer 1977, Lily Tomlin brought in her one-woman show *Appearing Nightly* to the Walnut following a successful run on Broadway. The show was a success at the Walnut as well, setting a record for box office receipts. (Courtesy of Jack Robinson, Hulton Archive, Getty Images.)

Box office records were broken again in the summer of 1978 when the musical *Eubie!* had its pre-Broadway tryout starring Gregory Hines (left) and Lynnie Godfrey. Hines, known now for an extensive theater, dance, television, and film career, was nominated for a Tony Award and won a Theatre World Award for his performance.

Bookings during the performing arts center years also included several rock and new wave groups popular in the late 1970s. Among those who performed in the spring of 1979 were the Police, a three-piece rock band consisting of (from left to right) guitarist Andy Summers, bassist/lead vocalist Gordon Sumner (better known as Sting), and drummer Stewart Copeland.

In October 1980, the Goodspeed Opera Company brought in a production of George M. Cohan's musical *Little Johnny Jones*. The photograph above shows the company with star Eric Weitz center. Much of the original 1904 score was lost, so holes in the show were patched with songs from other Cohan shows. In addition, the show was entirely rewritten to cut the running time from four hours to two. During the Walnut run, Donnie Osmond scouted the production as a possible star vehicle for himself, and when the show opened on Broadway, he played the leading role. On Broadway, the show ran for 29 preview performances and closed on opening night.

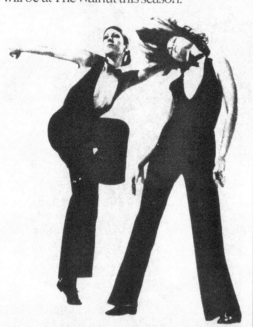

Twyla Tharp and four more of the hottest dance companies in America will be at The Walnut this season.

In May 1981, Twyla Tharp and her dance company came in to close out the Walnut season. In addition to her world-renowned dance company, Tharp has choreographed five Hollywood movies and directed and choreographed three Broadway shows, including *Movin' Out*, for which she received a 2003 Tony Award. In all, she has received one Tony Award, two Emmy Awards, 19 honorary doctorates, the Vietnam Veterans of America President's Award, and the 2004 National Medal of the Arts. (Courtesy of the Theatre Collection, Free Library of Philadelphia.)

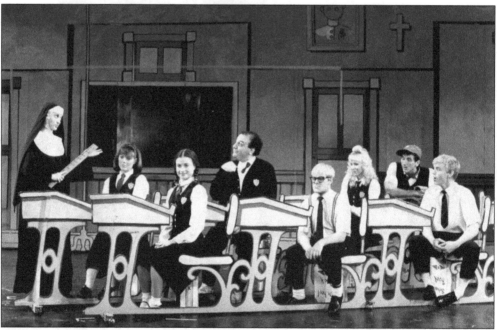

The musical *Do Black Patent Leather Shoes Really Reflect Up?* played at the Walnut for 22 weeks in the 1981–1982 season, making it one of the longest-running shows in Walnut history. Its Philadelphia success did not transfer with the show when it moved to Broadway, where it closed after five performances.

Six

FROM 1983 TO 2007

In 1982, Bernard Havard founded the Walnut Street Theatre Company as a self-producing, nonprofit regional theater with a vision of once again creating theater in a space that is so steeped in the American theater's history. A preseason presentation was Philadelphian Charles Fuller's 1982 Tony Award–winning best play, *A Soldier's Play*. The production, starring Samuel L. Jackson, also won the Pulitzer Prize for drama. The first season in 1983 included *A Flea in Her Ear*, *Oliver!*, *Morning's at Seven*, *A Perfect Gentleman*, and *The Taming of the Shrew*. It was a great success, and Philadelphia now had a new resident theater company with a commitment to developing a loyal subscription audience.

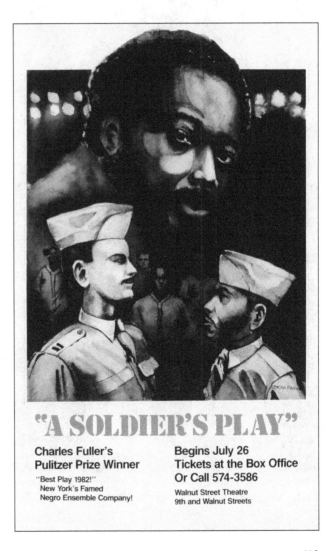

"A SOLDIER'S PLAY"

Charles Fuller's
Pulitzer Prize Winner
"Best Play 1982!"
New York's Famed
Negro Ensemble Company!

Begins July 26
Tickets at the Box Office
Or Call 574-3586
Walnut Street Theatre
9th and Walnut Streets

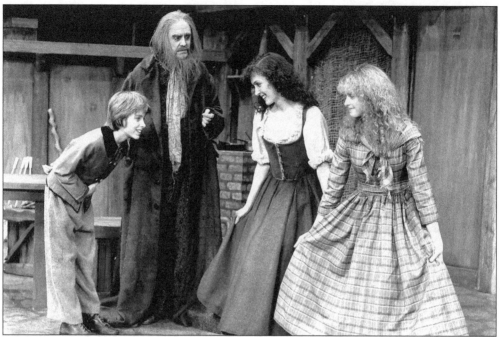

In 1983, *Oliver!* was the first musical produced by the Walnut Street Theatre Company. The cast included (from left to right) Tom Everly, Edmund Lyndeck, Katherine Buffaloe, and Nadine Isenegger. Lyndeck has had a successful Broadway career and is best known as Judge Turpin in the original Broadway production of *Sweeney Todd*.

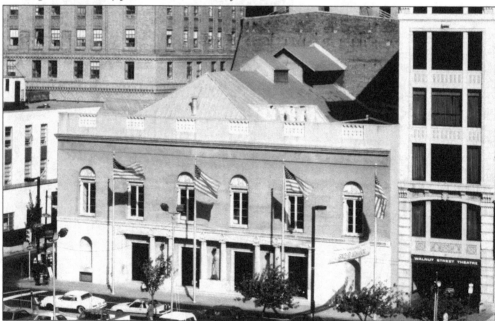

This exterior view of the Walnut is from 1985. The six-story structure to the right was connected to the historic theater as part of the 1969 renovations. This structure now contains the theater's box office, rehearsal halls, and administrative offices. There are also two additional black box theaters and spaces for the Walnut's popular theater school.

Delaware Valley native Hugh Panaro (left) and Jennifer Lee Andrews starred in the 1986 production of Stephen Sondheim's *A Little Night Music*. Panaro has gone on to star in Broadway productions, including *Les Miserables*, *The Phantom of the Opera*, *Side Show*, and *Lestat*. Andrews has returned to the Walnut over the years to appear in many productions.

Noises Off opened the Walnut's 1987–1988 season. This play by Michael Frayn is a backstage farce of all that can go wrong when rehearsing and performing a play. It is the basis for the 1992 film of the same name starring Carol Burnett, Michael Caine, Christopher Reeve, and John Ritter. The Walnut production featured (from left to right) Dudley Swetland, Erika Petersen, Mark Capri, and Millicent Martin. Martin, an international theater star, is best known as the original West End and Broadway star of *Side by Side by Sondheim* and television shows including *Frasier* and *Will and Grace*.

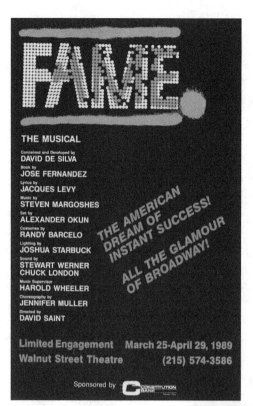

THE MUSICAL

Conceived and Developed by
DAVID DE SILVA

Book by
JOSE FERNANDEZ

Lyrics by
JACQUES LEVY

Music by
STEVEN MARGOSHES

Set by
ALEXANDER OKUN

Costumes by
RANDY BARCELO

Lighting by
JOSHUA STARBUCK

Sound by
STEWART WERNER
CHUCK LONDON

Music Supervisor
HAROLD WHEELER

Choreography by
JENNIFER MULLER

Directed by
DAVID SAINT

THE AMERICAN
DREAM OF
INSTANT SUCCESS!
ALL THE GLAMOUR
OF BROADWAY!

Limited Engagement March 25-April 29, 1989
Walnut Street Theatre (215) 574-3586

Sponsored by CONSTITUTION BANK

The world premiere production of *Fame! The Musical* transferred from Miami's Coconut Grove Playhouse to the Walnut in 1989. The show was conceived and developed by David DeSilva, who had created the 1980 award-winning film *Fame!* and the television series about New York's High School for the Performing Arts. The cast included Harold Perrineau Jr., best known today for the television series *Lost*. The show was a hit in Philadelphia and has since been produced in nearly 25 countries.

Concerto Soloists of Philadelphia, led by esteemed music director Marc Mostovoy (right), had played at the Walnut from 1975 until 1983. The ensemble returned to the Walnut in 1990 for six seasons. During this period, the Walnut Street Theatre Company provided the ensemble with management and marketing services. Today it is a resident company at Philadelphia's Kimmel Center for the Performing Arts. (Courtesy of Ira Kamens.)

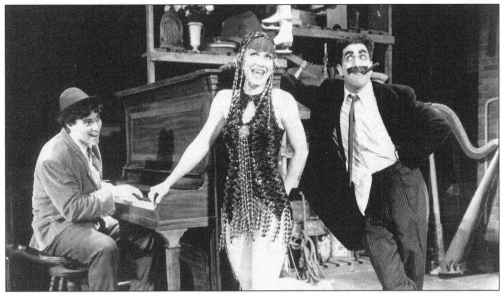

The 1992–1993 season concluded with *Groucho: A Life in Review*. The production featured, from left to right, Roy Abramsohn, Marguerite Lowell, and Frank Ferrante. Ferrante, who has been internationally acclaimed for his portrayals of Groucho, also played the role in New York, London, and in the PBS television version. Also an accomplished director, he has directed several Neil Simon productions at the Walnut, including *Laughter on the 23rd Floor* (in which he also starred), *The Sunshine Boys*, the trilogy of *Brighton Beach Memoirs*, *Biloxi Blues*, and *Broadway Bound*, and *Lost in Yonkers*.

A highlight of the 1993–1994 season was Linda Gabler (left) and Jamie Torcellini in the musical *Me and My Girl*. Philadelphia audiences went crazy over Torcellini's comedic performance. His Broadway appearances include Mistoffelees in *Cats*, LeFou in *Beauty and the Beast*, and the Barber in *Man of La Mancha*. He has frequently returned to the Walnut to star in productions, including *La Cage Aux Folles*, *Damn Yankees*, *Beauty and the Beast*, and *Man of La Mancha*.

In the spring of 1995, the Walnut produced the American premiere of the musical *Lust* by the Heather Brothers. The production featured Jennifer Lee Andrews (standing) and popular British actor Dennis Lawson. The show was so successful that it transferred to New York, where it enjoyed an extended engagement off Broadway.

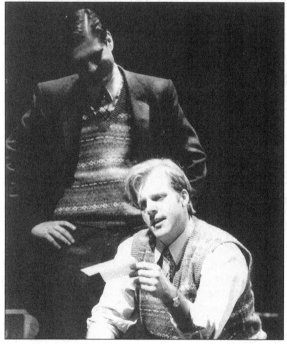

The 1995–1996 season included a production of *Philadelphia, Here I Come!* starring Ben Carlson (standing) and Jon Brent Curry. The play was directed by English-born director, producer, and writer Malcolm Black, who now resides in Canada. Over the years, Black has directed over 20 productions at the Walnut for both the Philadelphia Drama Guild and the Walnut Street Theatre Company.

To close the 1995–1996 season, the Walnut produced a new production of John Kander and Fred Ebb's musical *Cabaret*, starring Charles Abbott. Abbott reprised the role of the Emcee, a role he had created in the national tour of the original Broadway production directed by Harold Prince.

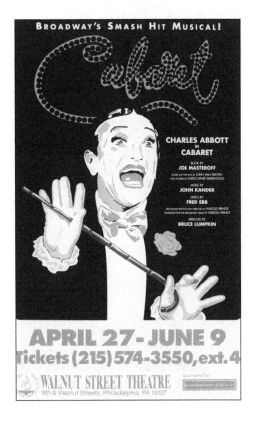

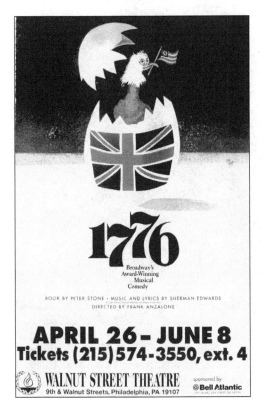

The final production of the 1996–1997 season was the musical *1776*, starring James Brennan as John Adams. Brennan also starred at the Walnut in the musicals *Camelot*, *Triumph of Love*, and *Crazy for You* and directed the musical *She Loves Me* in 2002. The musical *1776*, which tells the story of what happened at the Continental Congress in Philadelphia leading up to the signing of the Declaration of Independence, was staged by Frank Anzalone, who was the Walnut's stage manager for over 20 years.

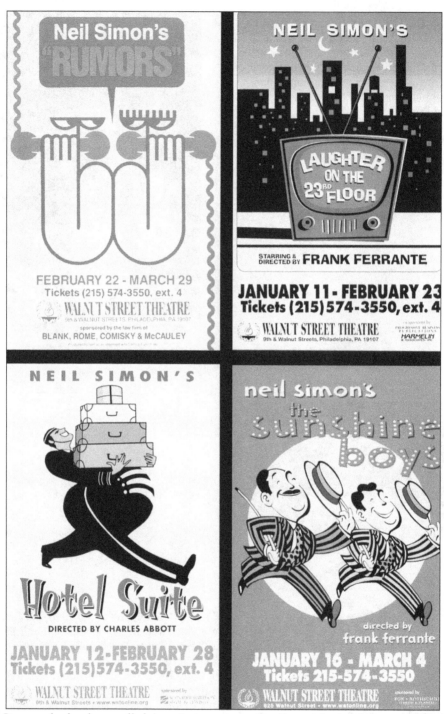

Neil Simon, who has been called America's most popular playwright, has been one of the most produced authors at the Walnut over the years. His popularity continued with productions of *Rumors* in 1992, *Laughter on the 23rd Floor* in 1997, the world premiere of *Hotel Suite* in 1999, and *The Sunshine Boys* in 2001. The Walnut also produced his play *Jake's Women* in 1993 and the musical *The Goodbye Girl* in 1997, with a book by Simon based on his hit movie.

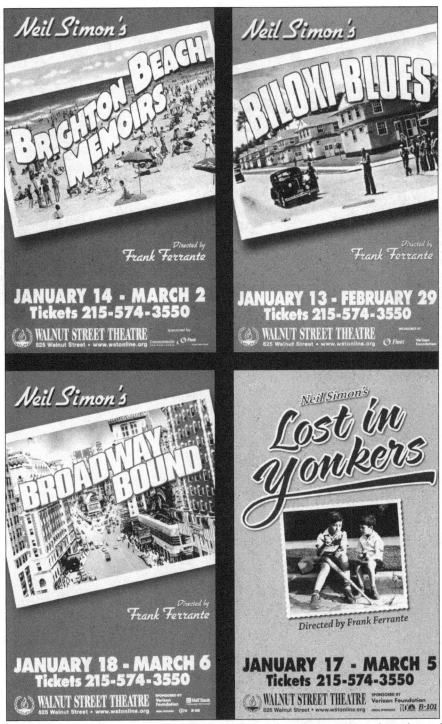

Over three seasons, starting in 2003, the Walnut produced Neil Simon's popular trilogy of plays *Brighton Beach Memoirs*, *Biloxi Blues*, and *Broadway Bound*. All three featured Jesse Bernstein as Simon's alter ego, Eugene Morris Jerome. This was followed by Simon's Pulitzer Prize–winning drama *Lost in Yonkers* in 2006.

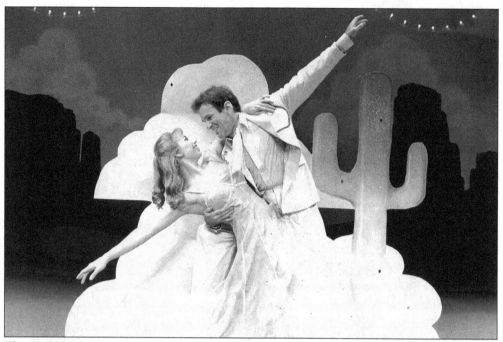

The 1997–1998 season included the George and Ira Gershwin musical *Crazy for You*, starring Darcie Roberts (left) and James Brennan. The production was directed by Charles Abbott, whose long association with the Walnut as an actor and director has spanned over 25 productions.

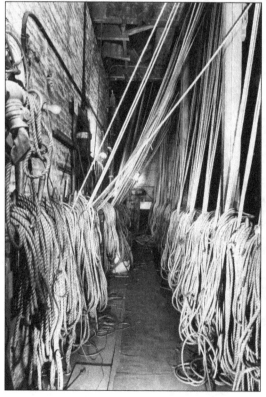

The Walnut is one of only a few remaining "hemp houses" in the country. To this day, it continues to operate the original grid, rope, pulley, and sandbag system that was in use two centuries ago. This photograph shows the fly loft where the key theatrical elements that are suspended above the stage, including pieces of scenery and lighting equipment, are manually controlled. In 2001, a multiyear major restoration of these historic stage systems was completed.

One of the biggest hits in the Walnut's history was *Buddy: The Buddy Holly Story* in 1999. The production, a musical celebration of the legendary singer/songwriter who shot to stardom in 1957 only to die in a plane crash two years later, featured Christopher Sutton (right) as Buddy Holly, shown here with actor Tif Luckenbill. Sutton has also appeared in Walnut productions of *Blood Brothers*, *Singin' in the Rain*, and *Finian's Rainbow*.

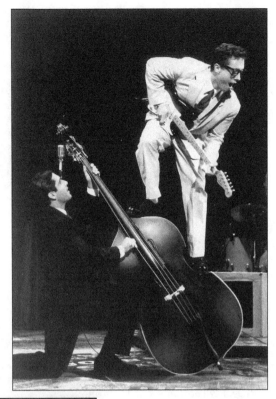

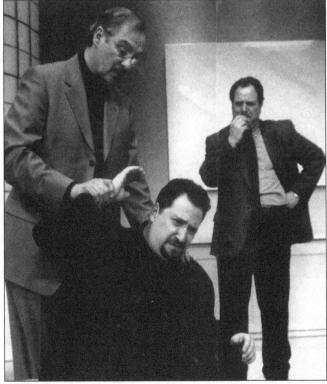

In 2002, producing artistic director Bernard Havard directed an acclaimed production of Yasmina Reza's award-winning play *ART*. The production starred (from left to right) Carl Shurr, Ben Lipitz, and Robert Ari.

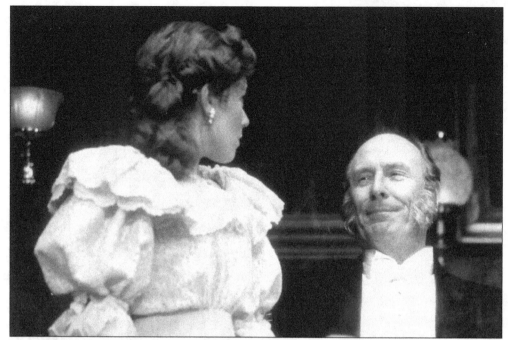

Harley Granville Barker's drama of manners and morals, *The Voysey Inheritance*, was part of the Walnut's 2002–2003 season. The cast included Sara Pauley (left) and Paxton Whitehead. Whitehead has 15 Broadway shows to his credit, including *Candida*, *Noises Off*, *Lettice and Lovage*, *My Fair Lady*, and *Camelot*.

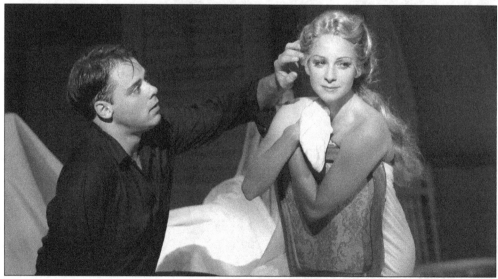

The 2003–2004 season opened with an American premiere of *La Vie en Bleu*, a French musical about the life of Pablo Picasso. The Walnut's production was greatly revised from the original and included a new book for American audiences. The production was staged by Bruce Lumpkin, who has directed over a dozen productions at the Walnut. It starred popular Philadelphia actor Jeffrey Coon (left) as Picasso and Jessica Boevers as his lover Eva Humbert. Coon has performed in over a dozen Walnut productions, and Boevers's Broadway career includes stints as Ado Annie in the 2002 revival of *Oklahoma!* and Eponine in *Les Miserables*.

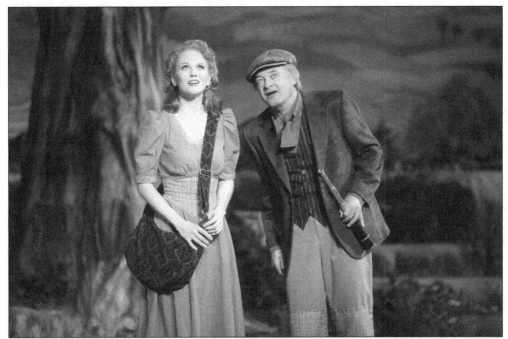

The 2005–2006 season opener, directed by Walnut veteran Malcolm Black, was the musical *Finian's Rainbow*, starring Jennifer Hope Wills (left) and Ian D. Clark. The show centers around Finian McLonergan (Clark), an Irish immigrant who comes to America with his daughter (Wills), and includes shades of political satire and deals with the issue of racism. Clark is a Canadian actor with an extensive television and theater career. Wills's Broadway credits include *The Phantom of the Opera*, *Beauty and the Beast*, and *Wonderful Town* with Brooke Shields.

Of Mice and Men played an important part of the 2006–2007 season. An adaptation of John Steinbeck's Nobel Prize–winning novella, the Walnut's production starred Scott Greer (left) as Lennie and Anthony Lawton as George. Greer, a local Philadelphia actor, began his career as an acting apprentice at the Walnut in 1992 and has appeared in many Walnut productions, including *Broadway Bound*, *Brighton Beach Memoirs*, *The Philadelphia Story*, *The Sunshine Boys*, and *Laughter on the 23rd Floor*.

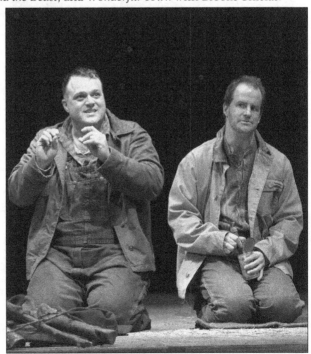

Mark D. Sylvester, managing director (left), joined the Walnut in 1994. He and founding producing artistic director Bernard Havard (right) comprise one of the longest-running and most successful management partnerships in the Walnut's history. Together they coauthored this book. (Courtesy of Kaitlyn Kenney.)

When Bernard Havard came to the Walnut, he started a tradition of his own. The mezzanine lobby walls hold the Walnut Street Theatre Company Gallery of Actors. Since 1982, an actor's headshot is added to the gallery the first time he or she appears in one of the company's productions. The 19th-century eagle that hung above the proscenium arch until the 1969 renovation is also located there, under a skylight.

In the summer of 1999, in a period of only six weeks, the Walnut underwent a major face-lift of the auditorium and lobbies. The walls were painted softer colors, more comfortable seating was installed, new carpeting was laid, and the number of public facilities was increased. There were also major upgrades made to the lighting and sound equipment and a "new to the Walnut" house curtain was hung. The plush curtain, donated by the Shubert Organization, was in like-new condition and had once hung at the Forrest Theatre, located two blocks west of the Walnut. The Walnut Street Theatre was designated as the state theater of Pennsylvania.

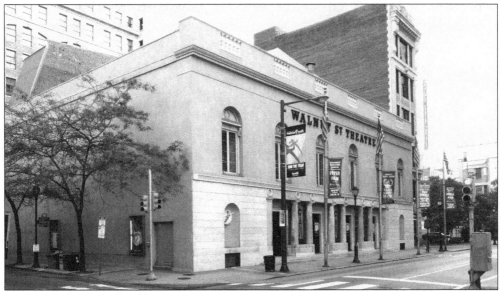

Today, with 200 years of history, America's oldest theater is entering its third century as one of the world's greatest theaters. With over 56,000 subscribers annually, the Walnut Street Theatre continues to be the most subscribed theater company in the world. Recently the theater acquired the adjacent property to its east and has plans to build an additional stage and expand its facility to meet the needs of the future.

ACROSS AMERICA, PEOPLE ARE DISCOVERING
SOMETHING WONDERFUL. *THEIR HERITAGE.*

Arcadia Publishing is the leading local history publisher in the United States. With more than 3,000 titles in print and hundreds of new titles released every year, Arcadia has extensive specialized experience chronicling the history of communities and celebrating America's hidden stories, bringing to life the people, places, and events from the past. To discover the history of other communities across the nation, please visit:

www.arcadiapublishing.com

Customized search tools allow you to find regional history books about the town where you grew up, the cities where your friends and family live, the town where your parents met, or even that retirement spot you've been dreaming about.

CPSIA information can be obtained
at www.ICGtesting.com
Printed in the USA
LVHW101426231219
641443LV00029B/1847/P